WELLS

THROUGH TIME

Stephen Tudsbery-Turner

AMBERLEY PUBLISHING

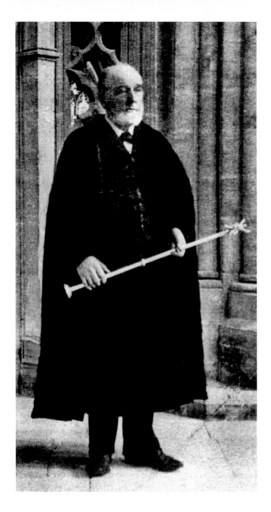

Portrait of T. W. (Thomas) Phillips.

For Hilary

First published 2011

Amberley Publishing
The Hill, Stroud
Gloucestershire, GL5 4EP

www.amberley-books.com

Copyright © Stephen Tudsbery-Turner, 2011

The right of Stephen Tudsbery-Turner to be
identified as the Author of this work has been
asserted in accordance with the Copyrights, Designs
and Patents Act 1988.

ISBN 978 1 84868 906 0

British Library Cataloguing in Publication Data.
A catalogue record for this book is available from
the British Library.

Typeset in 9.5pt on 12pt Celeste.
Typesetting by Amberley Publishing.
Printed in the UK.

Introduction

According to *Blackie's Popular Encyclopaedia* of 1869, the city of Wells in Somerset was 'situated in a diversified and picturesque country, having fertile and extensive meadows to the south, east and west. It is small, compact, generally well built and contains one of the most magnificent cathedrals in England.' Today, one might be forgiven for thinking that little has changed since then. True, the railway has disappeared and in its place the ubiquitous motor car reigns supreme. Houses have encroached upon the meadows, and the population has increased from 4,648 in 1861 to 10,406 in 2001. The cathedral, however, still dominates the city; the ancient gateways, the fifteenth-century deanery and the moated bishop's palace that dates back to the early thirteenth century still remain, together with one of the city's crowning glories, a tiny street of fourteenth-century houses.

The beauties of Victorian Wells were captured by various enthusiastic photographers who took advantage of a craze that was well established by the time Blackie's encyclopaedia appeared. Frank Dawkes and Harry Partridge ran the Cathedral Studio in the High Street, a leading photographic business during the Edwardian period. Both men were members of the Vicar's Choral and local legend has it that they were affectionately known in the city as 'Flash and Bang'. Their great rival at the turn of the century was Thomas Phillips of the Phillip's City Studio in the Market Place. It was a business that is thought to have been established about 1855. Its founder, John Budge, died in 1861 and when his widow Ann retired to run a boarding house five years later, she was succeeded by Thomas Phillips, her husband's former apprentice, and her own brother-in-law. A few years before his death in 1914, Thomas Phillips handed over the studio to his second son Bert, who in turn passed it to his former assistant Mrs Southwood in 1949. On the expiry of her lease thirty years later, Mrs Southwood retired and the business closed.

The photographs produced by the Phillips City Studio have provided the staple for *Wells Through Time*. When compared with modern images, they show that in the north-west, around the cathedral, little has changed as far as the look of the city is concerned over the last century and a half. In the south-east, where the railway stations used to dominate the scene, it is a different story. New roads have appeared, old buildings have either disappeared or have been put to new uses, and the pace of life has altered. The age of the horse and cart has been replaced by that of the fast car and the articulated lorry and the nearest railway station is at Castle Cary, fifteen miles away. As one stands on the site of the old Somerset & Dorset Railway station and stares at the traffic on the new relief road, which by-passes the city centre, one is aware that the city has seen changes. Whether they are for better or for worse remains a matter of opinion.

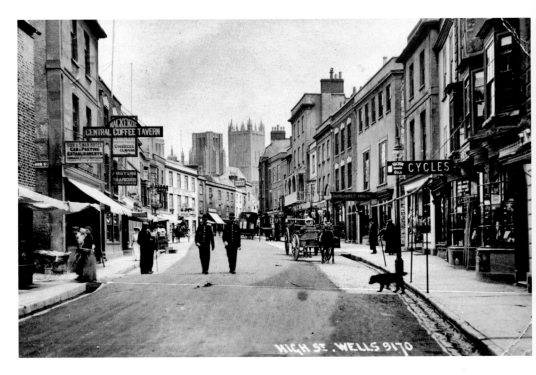

High Street, Wells in Edwardian Days.

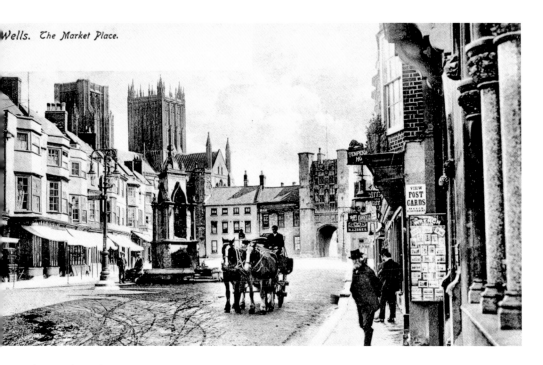

The Market Place

The market place is perhaps the logical starting point for our trip through time. Today it is a scene of activity. A hundred years ago, an air of tranquillity pervaded this focal point of the city, but the gentleman in the right foreground would easily recognise the setting if he returned. The cathedral dominates the background to the left and the gateway to the bishop's palace, albeit considerably modified, is clearly visible to the right. The fountain, which dates from 1793 and replaced a medieval conduit, still draws the eye into the centre of the picture. Only the horse and cart have gone.

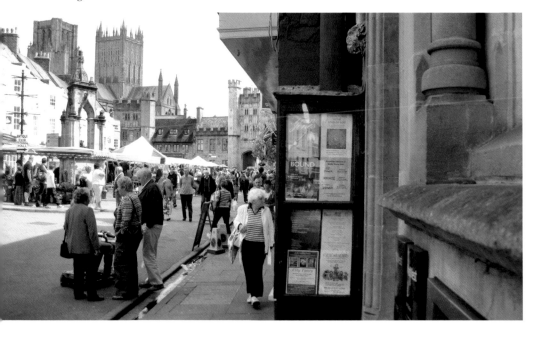

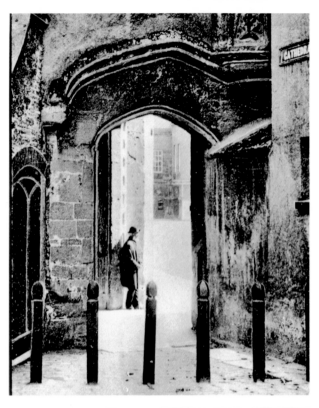

Penniless Porch from Cathedral Green

The Edwardian period was the hey-day of the picture postcard and Phillips City Studio took full advantage of this fact. This photograph of Penniless Porch, which links the Market Place with Cathedral Green and features an old gentleman with a brimmed hat, is one such example. The same view today shows that very little has changed over the last century, except for the removal of the posts and the disappearance of the old gentleman.

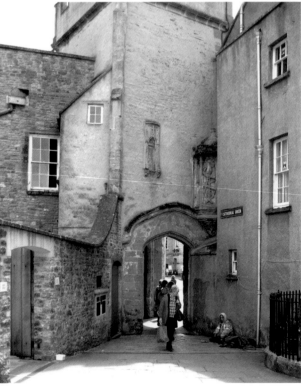

Penniless Porch from the Market Place
Dawkes and Partridge produced this
view of the porch from the market
place. Penniless Porch, or the Beggars'
Eye, as it was once called, dates from the
mid-fifteenth century and is so-called
because beggars congregated there to
solicit alms from travellers passing to
and from the cathedral. The battlements
and windows date from a restoration
in 1911–12, but it is unlikely that the
pilgrims in the lower photograph will
have noticed.

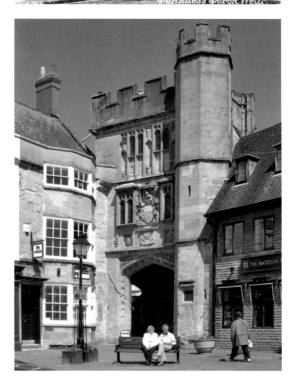

7

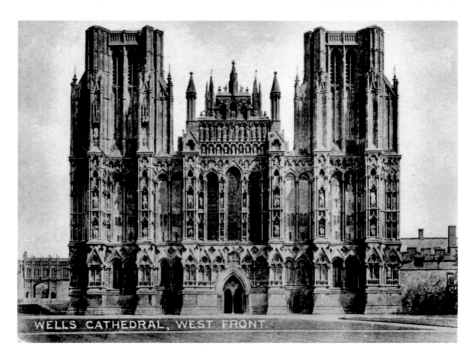

WELLS CATHEDRAL, WEST FRONT.

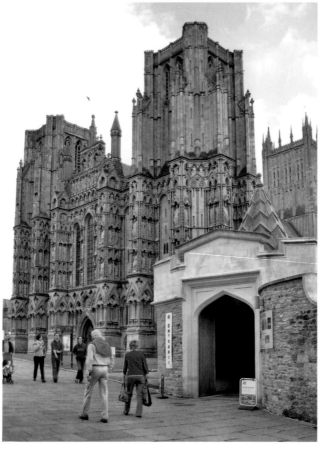

The West Front of Wells Cathedral The magnificent west front of Wells Cathedral with its bands of 297 sculptured figures may not have changed much since the thirteenth century but one significant addition to the cathedral in recent years has been the award-winning Friends' Building, seen to its right in the modern photograph. The statues, seen clearly in the earlier photograph by the London Stereoscopic Company, have been described as the greatest collection of medieval statuary in Europe.

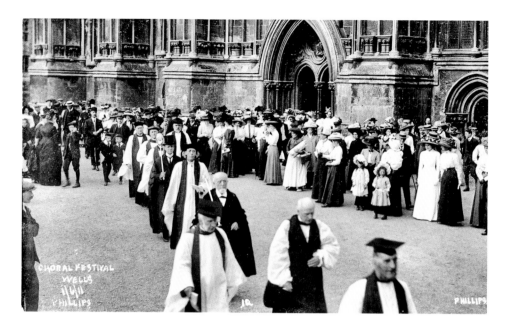

Choral Festival, 1 June 1911

The Choral Festival Procession is an annual event at the cathedral and this particular one took place on 1 June 1911. It features a bearded T. W. Phillips, seen in his black robes as cathedral verger, ahead of Dean Armitage Robinson. The procession is passing the west front of the cathedral, watched by an admiring crowd of ladies and gentlemen attired in their Sunday best. The dean, who moved from Westminster to Wells that same year, appears in an insert on our modern photograph.

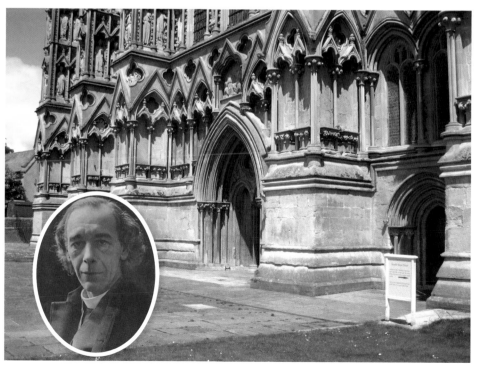

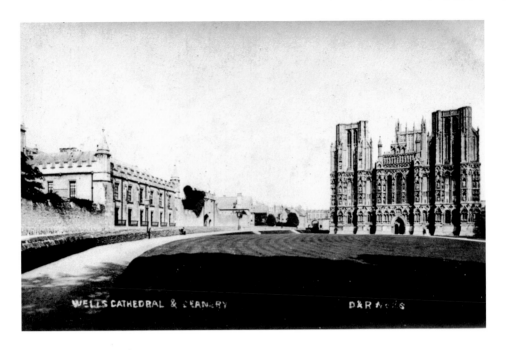

WELLS CATHEDRAL & DEANERY D&R M⸱⸱S

Cathedral Green and Deanery

The view across Cathedral Green towards the cathedral on the right and the deanery on the left has not altered in essentials over the years, although the dean would probably be both amazed and horrified to note the serried ranks of parked cars outside his front entrance.

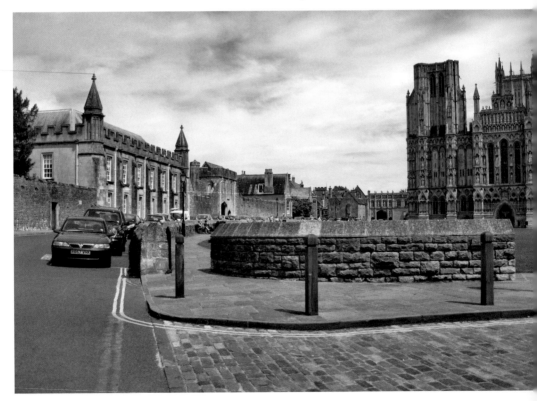

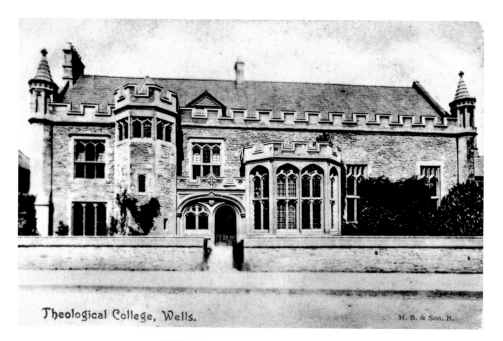

Theological College, Wells. H. B. & Son, B.

The Theological College
The old Archdeaconry looks much older than it is, for although parts of the building date back to the fourteenth century the façade is largely late nineteenth-century and would have been a little over ten years old when this photograph was taken. From 1890 to 1971 the building served as a theological college, but it is now the music school of the Cathedral School. Bishop Law (1824–45), who was instrumental in founding the Theological College, appears on our insert.

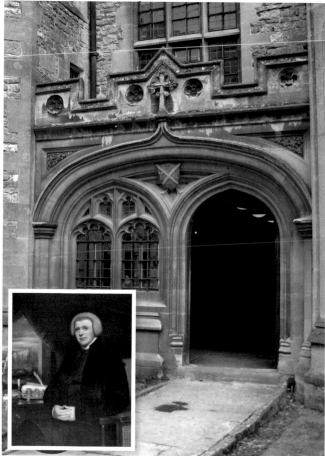

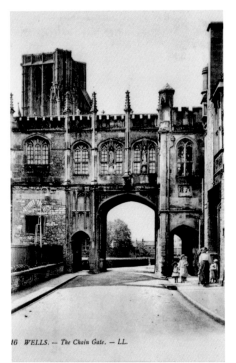

The Chain Gate From Outside

The Chain Gate, with the corridor above it, links the chapter house in the cathedral with the Common Hall at the south end of Vicars' Close. It was built by Bishop Bekynton, Bishop of Bath and Wells from 1443 to 1465. The Edwardian image shows the gate, with the chapter house off to the left of the picture. The modern photograph has been taken from the Cathedral Green side, with the cathedral on the right. The chapter house, bridge and Vicars' Hall are all clearly visible.

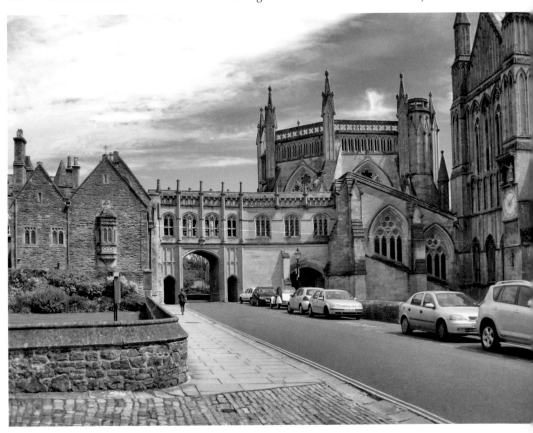

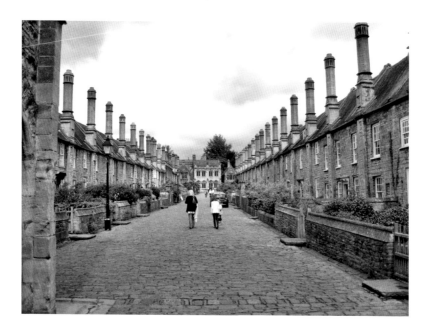

The Chapel

The Vicars' Close consists of two parallel rows of houses, built in the early fourteenth century and embellished after 1465 as a result of a bequest by Bishop Bekynton. There were originally forty-two in number, with a chapel at the north end and a common hall at the south. There are now fourteen double houses and twelve single. They were built for the Vicars' Choral, or cathedral choir, who today have been joined in the close by various cathedral employees. From the outside little has been altered since the day they were built, but inside they are now equipped with kitchens, bathrooms and all appropriate facilities. The charmingly decorated battlements of the chapel, seen here in the lower photograph, date from the fifteenth-century transformation, while the upper floor houses the Vicars' Library.

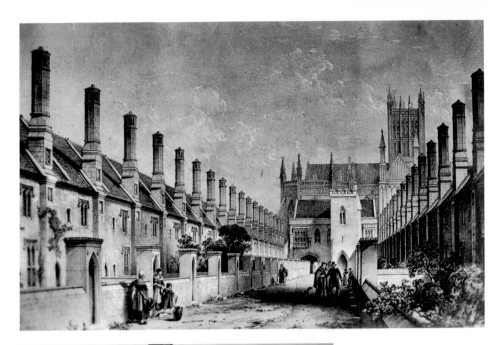

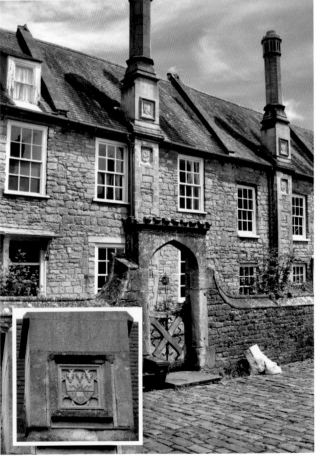

Vicars' Close

The Phillips City Studio produced a postcard of Vicars' Close taken from an old print. It shows the close in the early nineteenth century, when all the entrance arches were intact. The houses still retain the heraldic decoration put in place after 1465 and the Bekynton shield itself, which features a horizontal band between three bucks heads and as many arrow heads, appears on the insert. The chapel is a more complex structure than it first appears. The road narrows towards the north end, the road behind is at a slight angle and the pitch of the roof gradually changes. The false perspective thus obtained gives the impression that the chapel is square on, when in fact it is not.

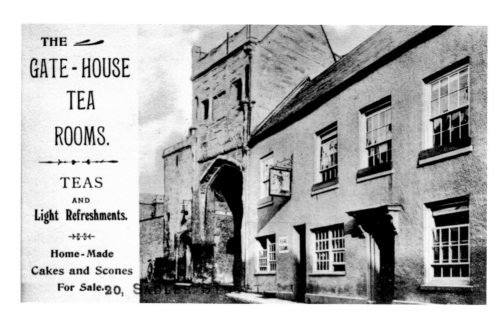

THE

GATE-HOUSE
TEA
ROOMS.

TEAS
AND
Light Refreshments.

Home-Made
Cakes and Scones
For Sale. 20, SADLER ST.

The Ancient Gatehouse

At the other end of Cathedral Green is what used to be called Brown's Gate, which leads on to Sadler Street. It is the second of the three gatehouses that open on to the cathedral precinct, the others being Penniless Porch and the Bishop's Eye. Our first picture shows the so-called Ancient Gate House in the 1920s, when Mrs E. W. Parrott ran it as a thriving private hotel and RAC restaurant. 'Boarding visitors are accommodated at separate tables apart from the Restaurant.' These days not that much has changed, as the former gatehouse now forms part of the adjoining hotel and Italian restaurant.

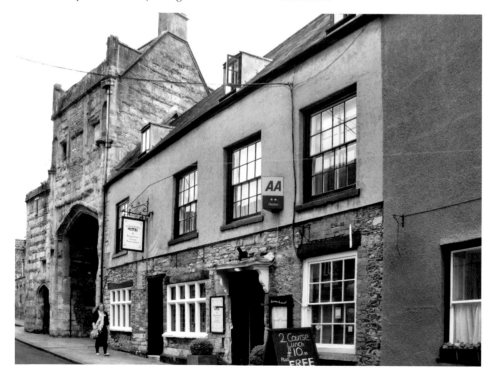

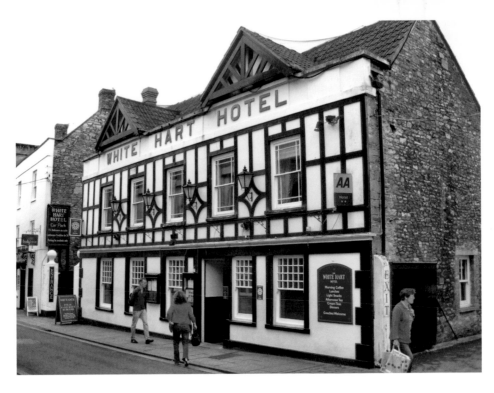

The White Hart Inn Yard

Nearly opposite the Ancient Gate House is the White Hart Inn. The inn yard to the right of the modern photograph is deserted, but a hundred years ago this was far from the case, as is shown by the lower image.

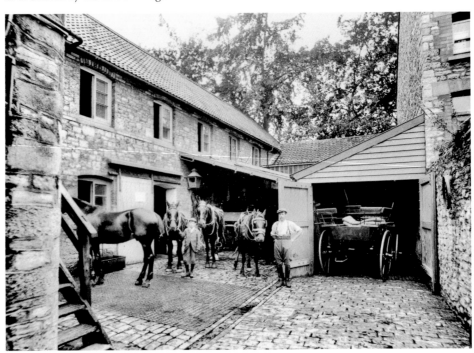

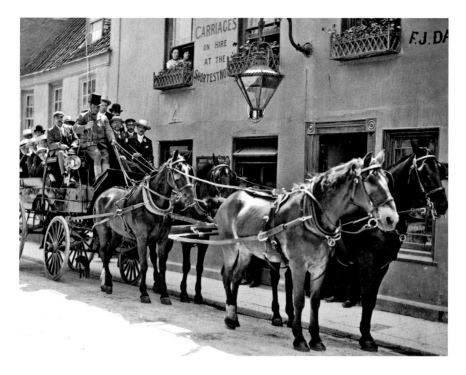

Excursion From the White Hart

An Edwardian excursion sets off from the White Hart in a wagonette pulled by four horses. The sign on the wall announces that saddle horses and carriages were available for hire at the shortest notice, a fact that would be only of academic interest to visitors today, who in our modern picture are alighting from their coach outside Brown's Gate.

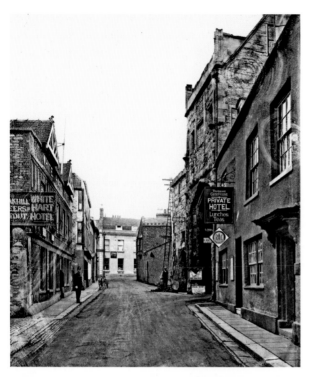

Sadler Street Looking North From the White Hart

The signboards for the White Hart Hotel and the Ancient Gatehouse Private Hotel are on display in this view up Sadler Street in the days of King Edward VII. A policeman poses for the camera opposite Brown's Gate, and on the right hand side of the road one can make out a labourer and his ladder. At the top of the street, Chamberlain Street goes off to the left and New Street to the right. Our modern photograph reveals the splendid door-case on No. 1 New Street.

Sadler Street Looking South From the White Hart

The aspect to the south from above Brown's Gate is enlivened by the inclusion of an open-top car and two figures – not to mention the same policeman who featured in the view looking north. It is clear from both the Phillips photograph and today's picture that there would be no problem about obtaining a pint of beer in Sadler Street at the tail end of Queen Victoria's reign. Next door to the White Hart inn was a beer house called the Nag's Head, and then came a hotel called the Mitre. Below that was, and still is, the prestigious Swan Hotel. The lower picture is of another interesting door-case, this time on a house opposite the Mitre that bears the date 1450 over the entrance.

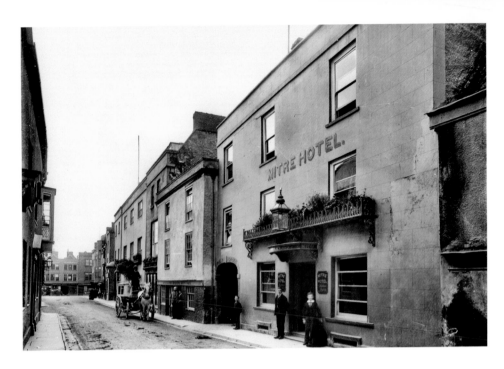

The Mitre Hotel

The Mitre Hotel at No. 17 Sadler Street was neatly sandwiched between the Swan Hotel to the south and the White Hart inn to the north. It is seen here with its omnibus, which brought residents to the hotel from the station. Today, the building is occupied by flats and an up-market shoe shop.

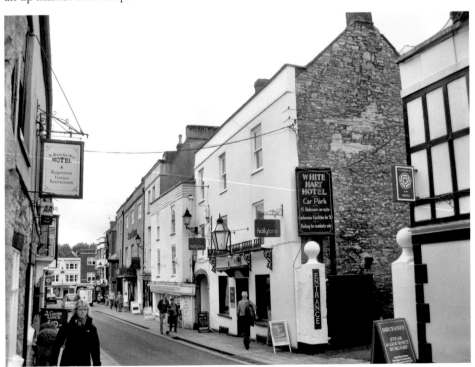

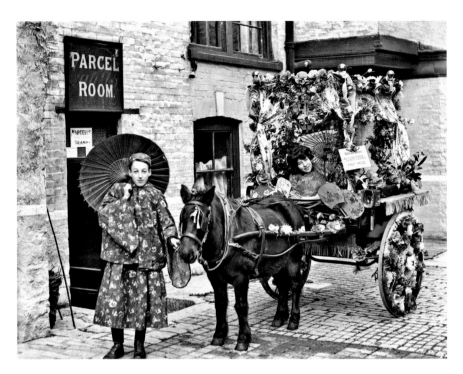

The Best Decorated Two-Wheeled Vehicle in the 1910 Carnival

Min Maude won first prize for the best decorated two-wheeled vehicle competition held at the Wells Carnival in 1910. The winning float is seen here in the yard of the Mitre Hotel. The notice 'Parcel Room' above the door to the left reminds one that the hotel was a pick-up point for local carriers. The modern photograph is of the Mitre yard almost exactly a century later. The Heritage Courtyard, as it is now called, is a centre for a variety of small businesses.

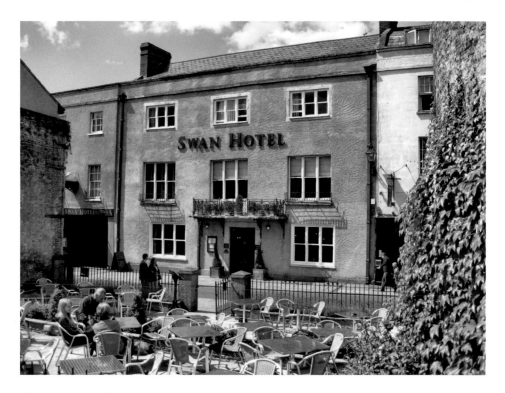

The Swan Hotel Cab

The Swan Hotel owned a tiny but attractive garden on the opposite side of Sadler Street and was thus able to claim that it was the only hotel from which a view of the cathedral could be obtained, a claim that presumably holds good today. Whereas modern visitors often arrive at the hotel by coach, a hundred years ago they would probably have been carried from the station by the Swan Hotel's omnibus, pictured here outside the Palace Gatehouse.

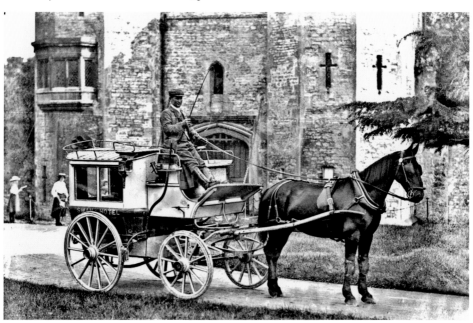

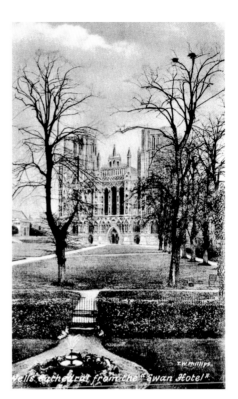

Cathedral from Swan Hotel

The name T. W. Phillips is clearly visible on this postcard showing the Swan Hotel's garden and the excellent view of the cathedral. The trees are rather smaller in our modern photograph and the flower bed and sun dial have been replaced by tables and chairs for the use of the hotel's clientele.

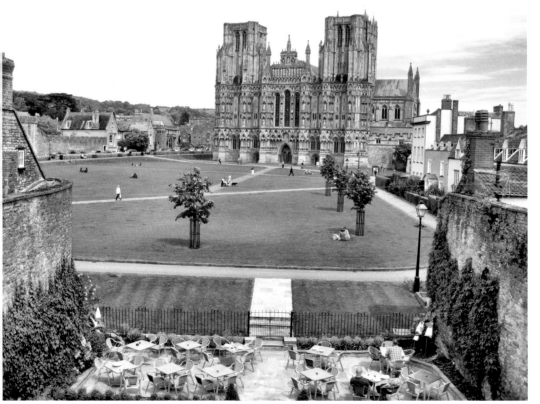

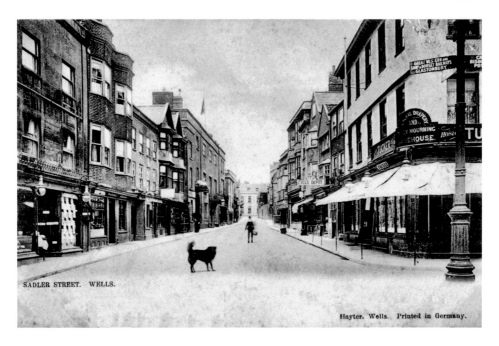

SADLER STREET. WELLS.

Hayter. Wells. Printed in Germany.

Sadler Street Looking North From the Market Place

Sadler Street links the Market Place to the south with New Street in the north and was named after John Sadler, Mayor of Wells in 1463 and again in 1471. This postcard was produced by Charles Hayter, a stationer, who ran the post office at No. 1 Priory Road during the late Victorian and Edwardian periods. All in all, very little seems to have changed over the course of a hundred years, barring of course the volume of traffic.

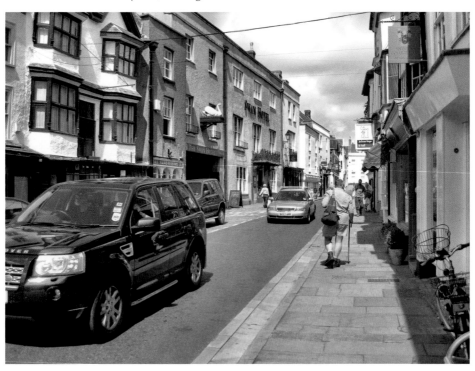

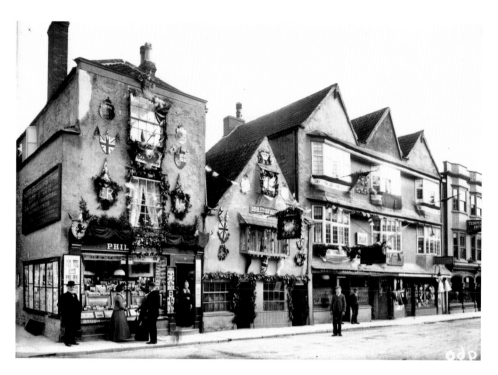

The Phillips Shop, the Royal Oak and the Crown Hotel

Phillips' shop at No. 10 Market Place, suitably decorated to celebrate the coronation of King Edward VII and Queen Alexandra, is seen here at the other end of the Market Place, next to the Royal Oak beer house and the Crown Hotel. T. W. Phillips is seen standing to the left of the picture.

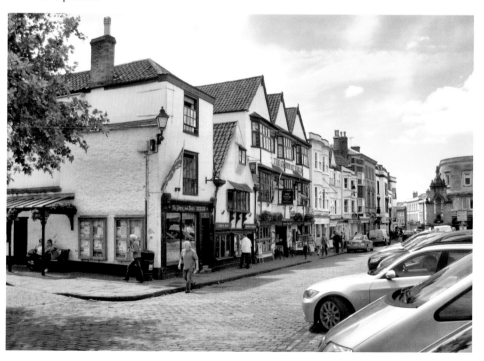

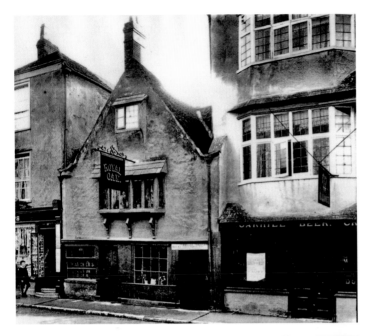

The Royal Oak

Today, the Crown has taken over both the shop and the beer house. The latter is known as Penn's Bar to commemorate an occasion in 1694 when the Quaker William Penn preached from the upstairs window. In 1907 the Royal Oak closed and T. W. Phillips leased the premises from the Corporation, which had taken over the property a few years earlier.

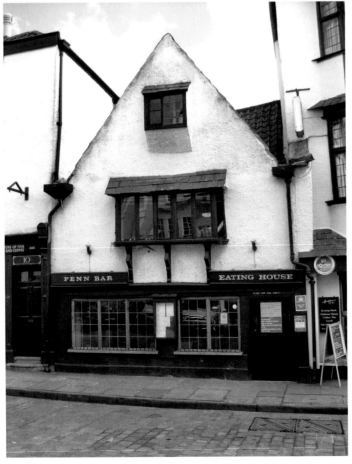

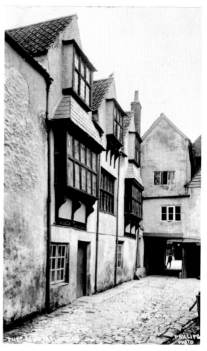

The Crown Courtyard

T. W. Phillips died in 1914 but his son Bert continued the business, and just after the war he acquired No. 4 Market Place, part of the Crown frontage, which he ran as a toy shop. He further expanded the Phillips empire by opening an antique shop at No. 5 Market Place, on the north side of the Market Place. The Phillips photograph here shows the Crown courtyard as it was in Edwardian days. A century later, the yard is used by the hotel's customers and the covered section beyond is now part of the reception area.

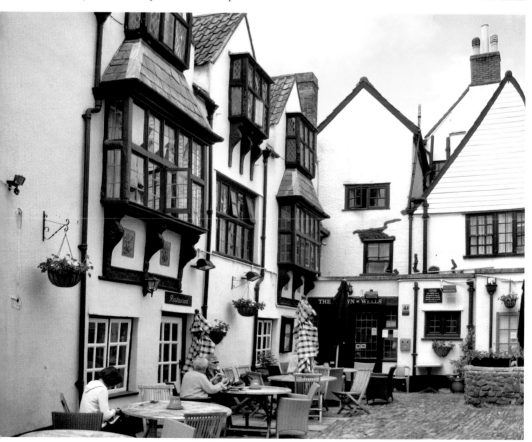

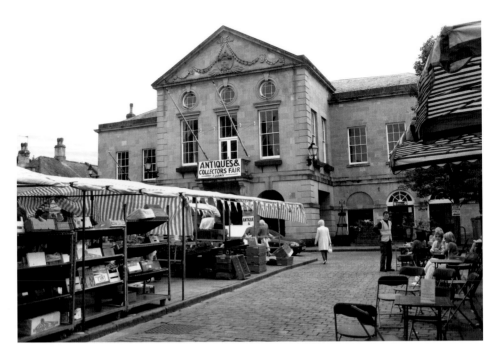

The Town Hall and the Empire Day Celebrations of 1905

The Town Hall in the south-eastern corner of the Market Place was built in 1779, although there have been several later additions. Thomas Phillips photographed the Empire Day celebrations in front of the hall on 24 May 1905. He would not have recognised the balcony and bulls-eye windows, which were installed during the 1930s. At the same time, today's shoppers at the Wednesday market are unlikely to be familiar with Empire Day celebrations – the date being the birthday of Queen Victoria.

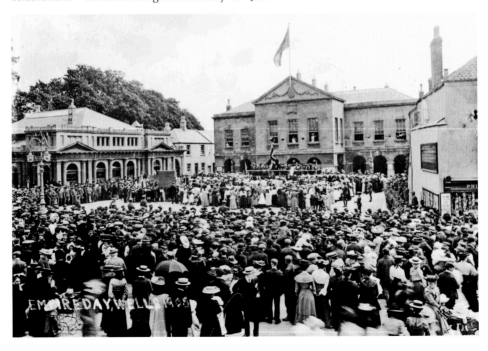

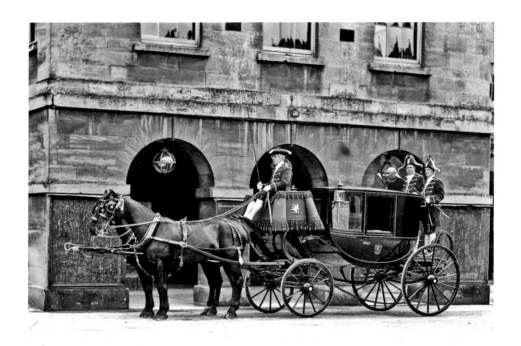

The Town Hall Portico

The Town Hall's portico, a three-bay arcaded centre-piece, is Victorian, and in our 1906 photograph it is embellished by the addition of a handsome coach manned by a coachman and two liveried footmen. The modern photograph makes up for the lack of a coach by the addition of a rather attractive floral display.

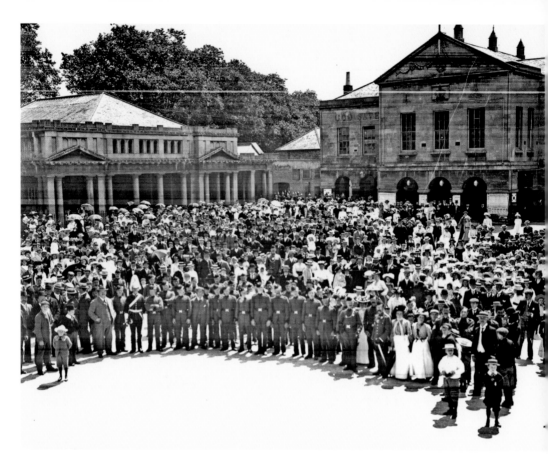

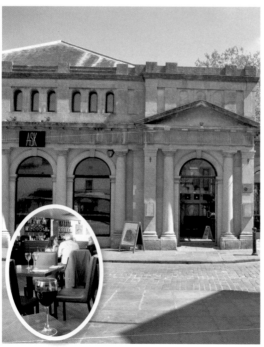

The Market Hall

This building to the left of the Town Hall dates from 1835 and started life as the Market Hall. Since about 1903 the frontage has been enclosed by a low Tuscan façade with pilasters and attached columns, but it was originally colonnaded and open, as illustrated by our Phillips photograph, which was taken at the turn of the century and possibly celebrates the end of the Boer War. In 1923 the Market Hall became a post office and at present the left hand section continues in that role, while the right serves as a restaurant.

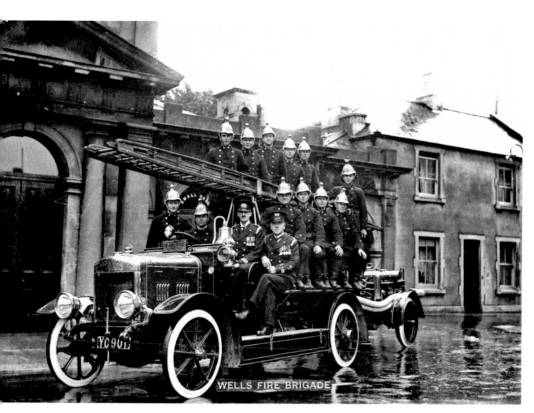

WELLS FIRE BRIGADE

The Fire Station

The local fire brigade was established in 1874 and during the 1920s the fire engine was housed at the right hand end of the Market Hall. For twenty-two years Bert Phillips was a member of the Volunteer Fire Brigade and the Phillips Shop at No. 10 Market Place could hardly have been handier for an emergency call-out. In our modern photograph a row of red wheelie bins marks the entrance to the one-time fire station.

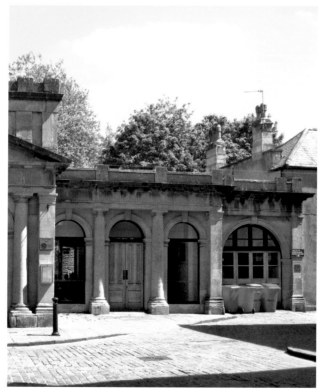

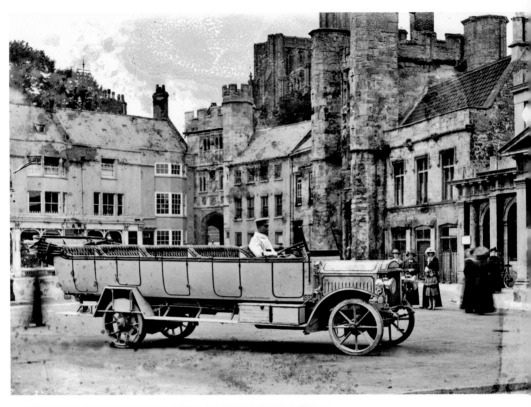

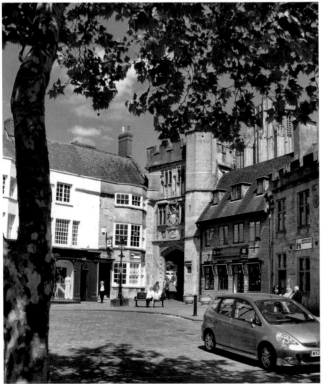

Edwardian Charabanc in the Market Place

The Phillips City Studio view of the Market Place takes in part of Clare's store, the Penniless Porch and the Bishop's Eye, the entrance to the Bishop's Palace grounds. The architectural features, however, pale into insignificance beside this imposing Edwardian charabanc, which dominates the scene. Today's visitors to the Market Place will have arrived in a far more mundane fashion.

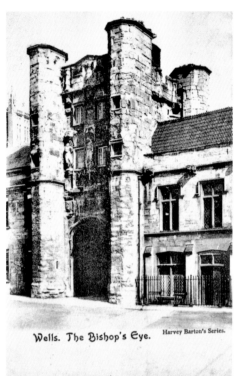

Wells. The Bishop's Eye. Harvey Barton's Series.

The Bishop's Eye Before 1907

The Bishop's Eye, or Palace Eye, the third of the three gatehouses that link the city with the cathedral precincts, has seen its changes over the years. The Edwardian picture seen here dates from before the removal of windows in the turrets and the addition of battlements in the centre of the tower in 1907. Today's image shows the view through the archway to the palace precincts beyond.

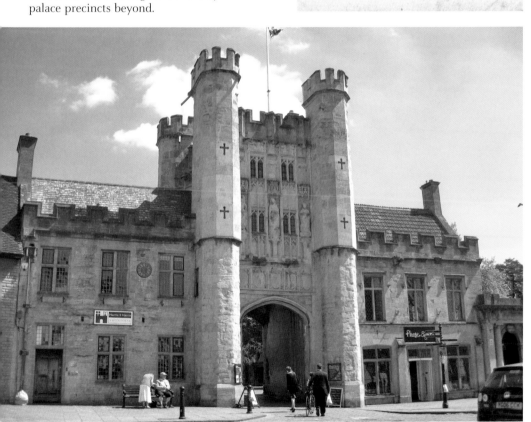

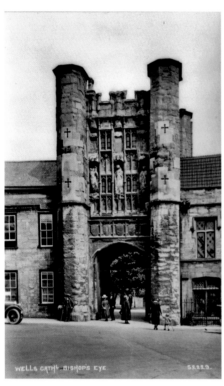

WELLS CATH^L BISHOPS EYE 52229

The Bishop's Eye and its Battlements

The delightfully animated inter-war photograph above shows the battlements that were added in the Edwardian period. Those on the adjoining buildings that are shown in the lower picture were added in 1927, while those on the turrets date from a further restoration in 1991.

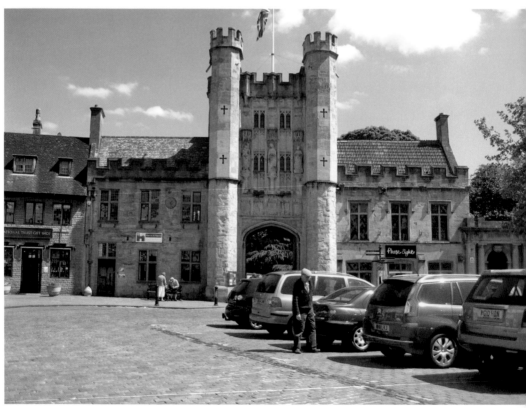

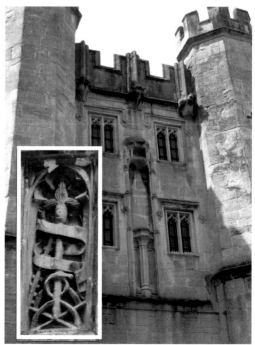

Wells, The Palace Eye.

The Missing Statue and the Bishop's Rebus

The upper photograph, taken during the first decade of the twentieth century, shows the Bishop's Eye from within the palace grounds and reveals both the central section and the turrets without their battlements. The lower picture not only shows the new battlements, but also draws attention to the fact that the statue between the windows is missing. It disappeared in the mid-1950s. Another, less dramatic, change is that the railings leading up to the archway have also disappeared. On the wall to the left of the entrance is the rebus of Bishop Bekynton, who built the gatehouse. The rebus, a pictorial representation of the bishop's name, is made up of a flaming tar barrel on a pole (a beacon) in a barrel or tun – thus Beacon-tun.

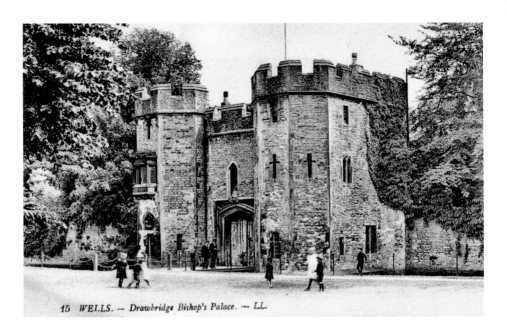

15 *WELLS. — Drawbridge Bishop's Palace. — LL.*

The Gatehouse

Plenty of visitors are to be seen in this photograph of the early fourteenth-century Palace Gatehouse by the French firm LL. The drawbridge was last used in 1831, at the time of the Bristol Riots over the Reform Bill. It remained in working order for another hundred years, and then was converted to a permanent roadway for the use of today's less belligerent tourists.

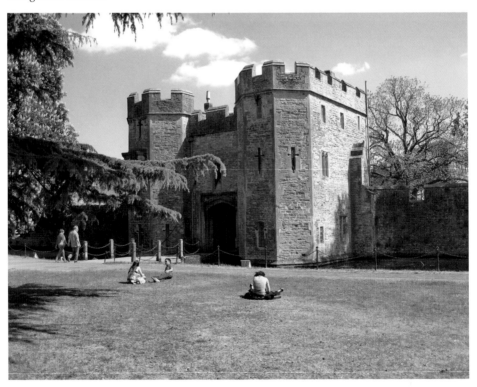

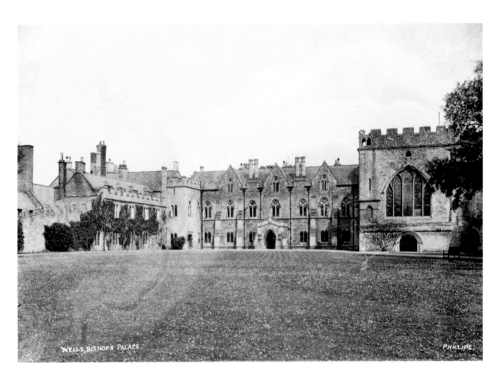

The Bishop's Palace

As far as the architecture is concerned, little has altered since the Bishop's Palace was restored and enlarged by the architect Benjamin Ferrey in the middle of the nineteenth century. The central range takes in the original thirteenth-century house, the north range to the left was built by Bishop Bekynton in the early fifteenth century and the chapel to the right is late thirteenth-century. The modern photograph, which features a rather splendid magnolia tree, shows that nature rather than man has been responsible for the only change over time.

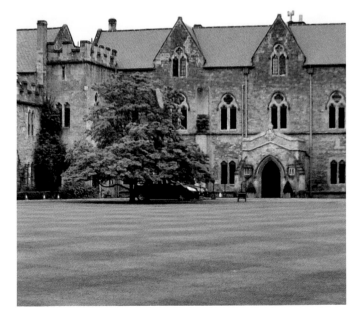

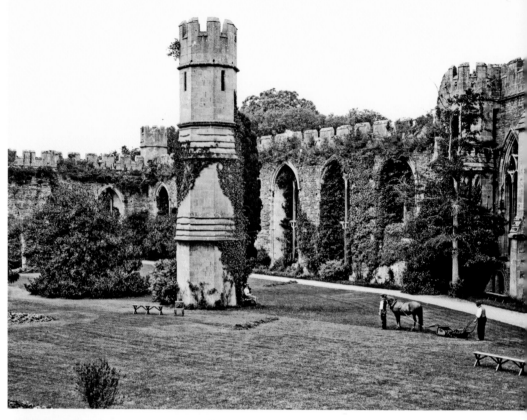

The Bishop's Garden

The old palace hall, turned into a romantic ruin by Bishop Law in the early nineteenth century, forms the backdrop for the Bishop's Garden, as photographed *c.* 1905. The horse-drawn lawnmower provides a nice Edwardian touch. At present, the trees have all but obliterated the view of the solitary tower that was the focal point of the bishop's creation.

The North Range of the Palace

The north range of the Bishop's Palace, seen here from across the moat, has been enlivened by the appearance of a liveried footman, obviously intrigued by the activities of Thomas Phillips, who took this photograph *c.* 1895. Little has changed today, bar the disappearance of the inquisitive servant.

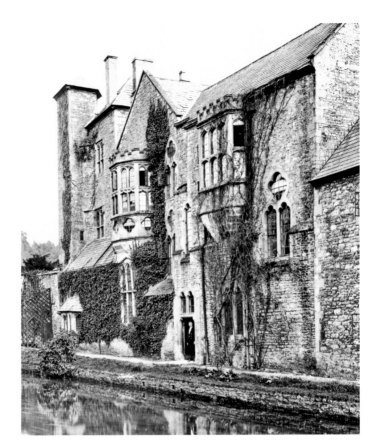

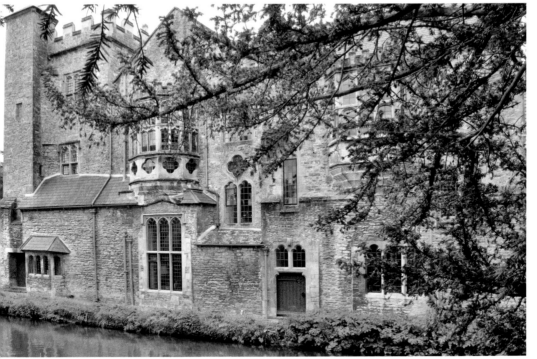

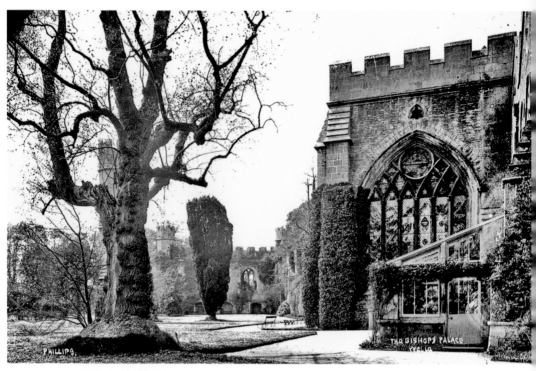

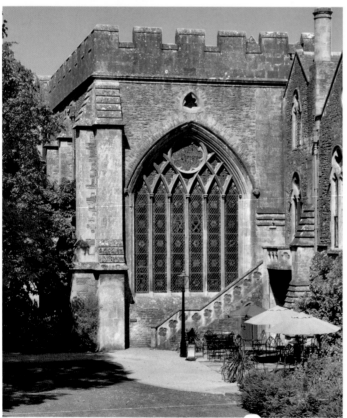

The Chapel Window and the Missing Conservatory

Robert Burnell, bishop from 1275 to 1293, built the now ruined banqueting hall, as well as the magnificent chapel to the right of the palace's central block. The contemporary view highlights its splendid east window, while the Phillips City Studio picture informs us that in Edwardian days there was a conservatory where today's visitors are able to purchase a cup of tea.

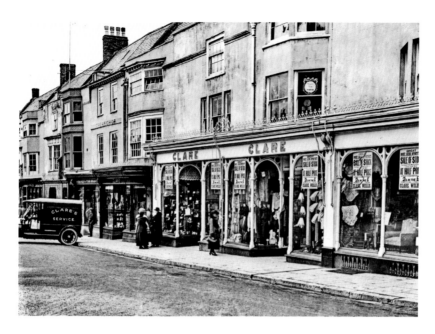

Clare's Store

Clare's was the most prominent shop on the north side of the Market Place during the inter-war period. The original Mr Clare arrived in Wells from Norfolk in 1900 and set up a drapery business in the High Street. He then teamed up with a Mr Holloway, who ran a concern in the Market Place, and ultimately Clare became the sole proprietor. The business expanded and absorbed various local concerns, but after the Second World War certain divisions were sold off and what is left today is a thriving wirework production company based in the Parkwood Estate outside the city. Currently, the Market Place premises are occupied by a variety of independent traders.

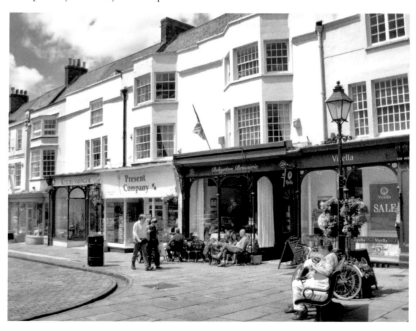

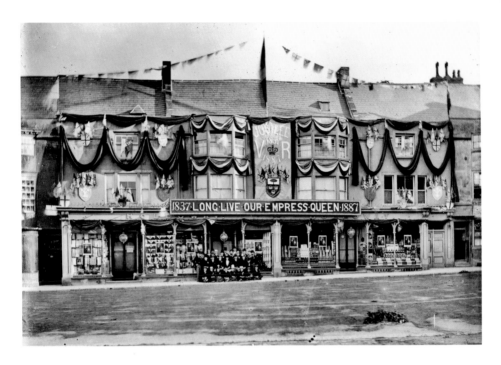

Celebrations outside Holloways

Here we have the same store in the days when Mr Holloway was the sole proprietor. The decorations celebrate the Golden Jubilee of Queen Victoria. Outside the store, the pavement brass commemorates the achievement of Mary Rand at the 1964 Tokyo Olympics, when the Wells-born athlete won a gold medal with a winning long jump of 22 feet 2 inches.

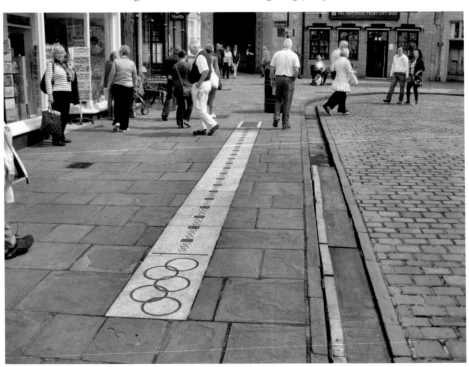

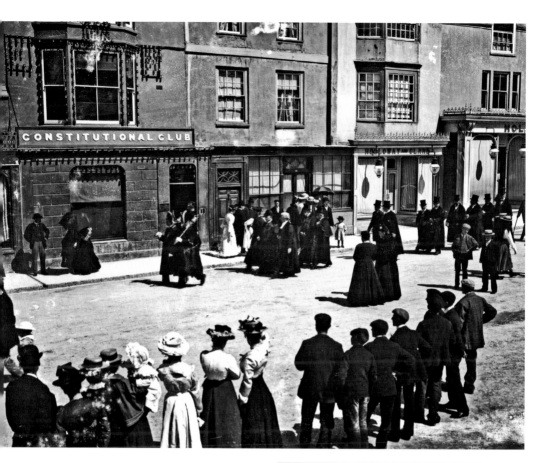

The Civic Procession

The Mayor's mace is being carried at the head of this civic procession that is passing Clare and Holloway's store and is heading in the direction of the junction with Sadler Street. The date is 1902, the year of the coronation of King Edward VII. The Constitutional Club has since become the Conservative Club and the bunting in our lower photograph celebrates the marriage of the Duke and Duchess of Cambridge.

The Wheelbarrow Contest of 1908

On Wednesdays and Saturdays, this corner of the Market Place, with Sadler Street off to the right, is occupied by market stalls. A century ago it was also crowded, on that occasion by participants and spectators concerned with the 1908 wheelbarrow contest.

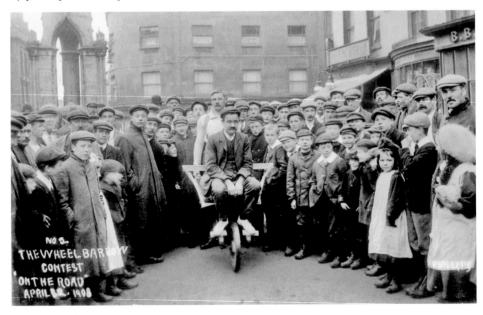

The Russian Gun

The Russian Gun was donated to the city as a token of appreciation for the efforts made by troops from Wells during the Crimean War. It was originally situated in the centre of the Market Place, but ultimately ended up just east of the fountain. In 1943 the gun was broken up for scrap in aid of the war effort – a futile gesture, because the metal proved to be unsuitable for use. Its former location is now occupied by a parked car.

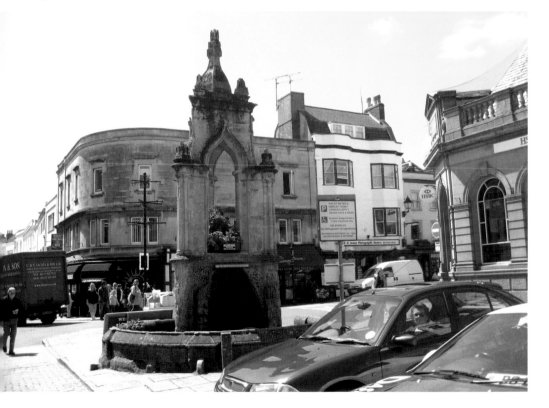

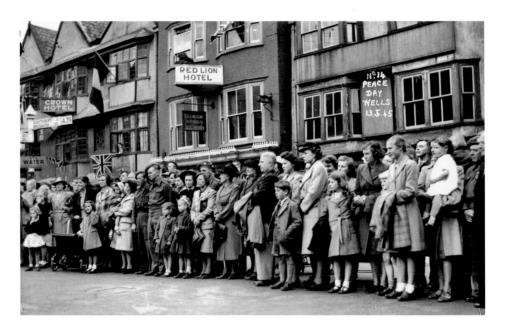

Peace Day, 13 May 1945
Crowds line the south side of the Market Place in front of the Red Lion Hotel to celebrate the end of the war with Germany in June 1945. In Edwardian days the hotel was the Temperance Hotel and must have been an uneasy neighbour to the rather more alcoholic Crown. It changed its nature during the inter-war period, while today it houses flats and shops. The basic structure of the building remains the same, but the brickwork has been rendered and the ground floor has been altered to cope with modern requirements.

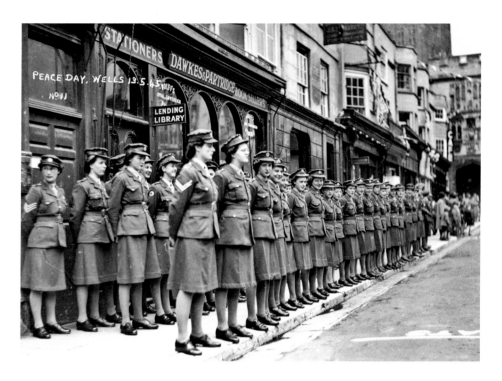

Peace Day with the ATS

On the opposite side of the Market Place, in front of Dawkes & Partridge's Stationer's shop, the ATS lines up in all its glory. Both Frank Dawkes and Harry Partridge had died during the war, but shortly before this they had disposed of their photographic business in the High Street and had moved to the Market Place where, according to Harry Partridge's obituary, 'they were successors to Mrs Radnedge at Ye Old Central Library'. Their rather charming shop front has been replaced by the bland exterior of Barclay's Bank.

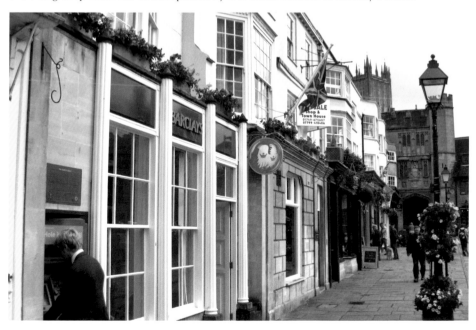

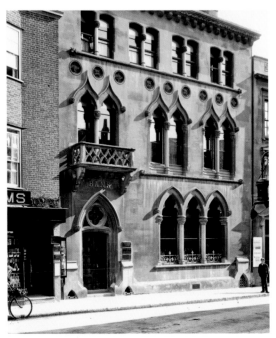

Stuckey's Bank

Stuckey's Bank at No. 7 High Street opened in Wells in 1825, although it was then housed at No. 9. This splendid neo-gothic building dates from 1855 and replaced the George Inn, which was a thriving concern in Bishop Bekynton's day. The premises still house a bank – this time the National Westminster – but the frontage was modified in the early twentieth century.

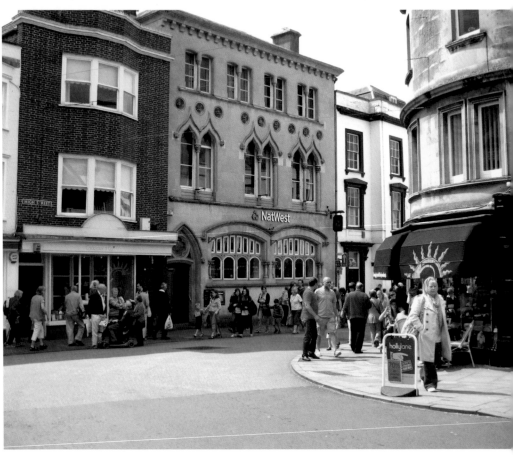

New Street, the Liberty and Mullins House
This inter-war street map of Wells clearly shows
the roads that lead out of the city to the north of
the cathedral; New Street to the north and Bristol,
St Thomas Street to the east and Frome, and
Tor Street to the south-east and Shepton Mallet.
Mullins House, a graceful Georgian residence
which is now part of the Cathedral School, is
located on the junction of New Street and The
Liberty, just above the modern roundabout.

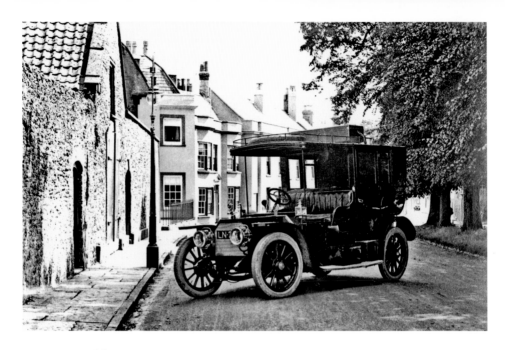

New Street with Motor Car

This splendid car is parked just above The Hollies in New Street. It would not last long in that position today, as the modern picture makes clear. This second photograph has been taken from exactly the same position as the earlier Edwardian picture, but our photographer is facing in the opposite direction. The traffic from the right and Bristol heads into Wells along New Street, while to the left the A39 forms part of the modern relief road.

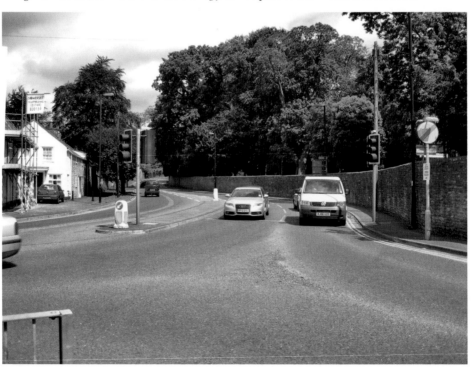

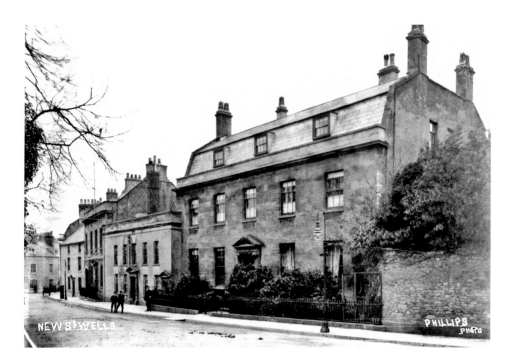

Ritchie House

At the time Phillips took this photograph in 1910, Ritchie House, an attractive late Georgian five bay mansion at the end of the lower section of New Street, was privately owned. Seventeen years later it housed the Girl's High School, founded in 1888, which moved from premises above the west cloister of the cathedral. Since 1947 it has been owned by the Cathedral School, which uses it as a boys' house for the Upper School.

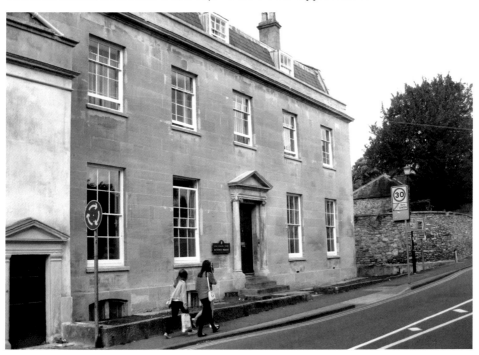

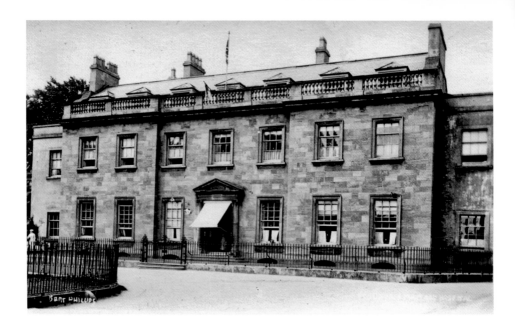

The Cedars

The Cedars, a handsome Georgian mansion that fronts North Liberty, was built for Charles Tudway, MP for Wells, in 1758. The Tudways moved out shortly before the First World War, when the house served as a military hospital. It then became a home for the theological college before being acquired by the Cathedral School in 1967. It is currently an Upper School house for boys. The railings that are so obvious in Bert Phillips's photograph were a casualty of the demand for metal scrap in the 1940s.

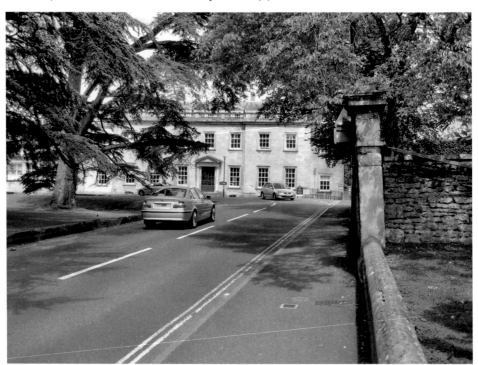

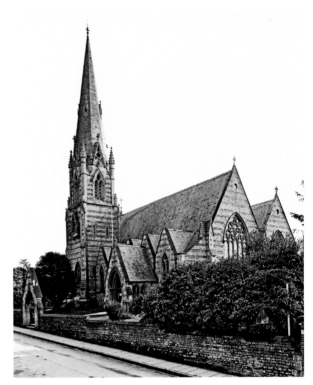

St Thomas's Church

St Thomas's Street, formerly East Wells, takes its name from the church that was built there in 1856/7, the architect being S. S. Teulon. The church has a north-east tower and spire and is built of stone with brick bands. These days, the road alongside the church is invariably lined with parked cars.

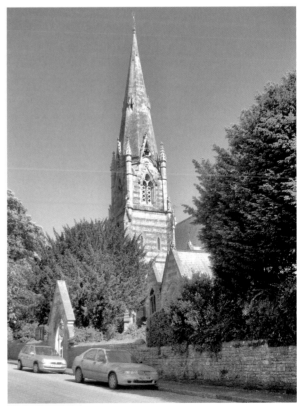

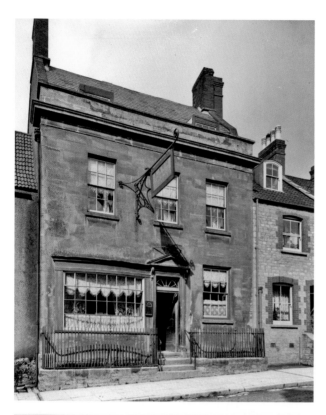

The Lamb Inn

The Lamb Inn was one of six inns that existed in East Wells in the 1850s. It was situated on the left hand side of the road on the way up to the church, and the building still survives today as a private house. The house next door – the yellow one in the modern picture – was formerly the Somerset Inn. An obvious change that has occurred over the last hundred years is the absence of the railings.

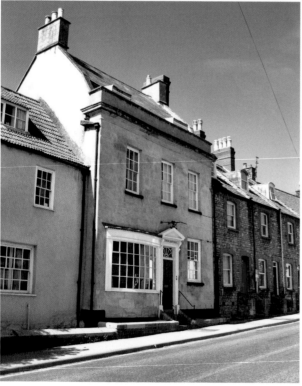

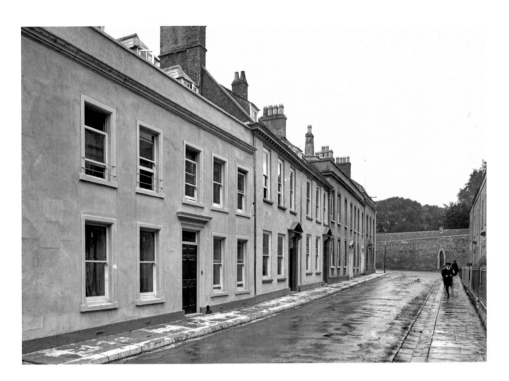

Chamberlain Street

The boy approaching the photographer in the Phillips view of Chamberlain Street is walking from the direction of the Sadler Street turning to the right. In the distance is the wall beyond which is Cathedral Green. A residential close now exists behind the wall, but other than that the view is much the same.

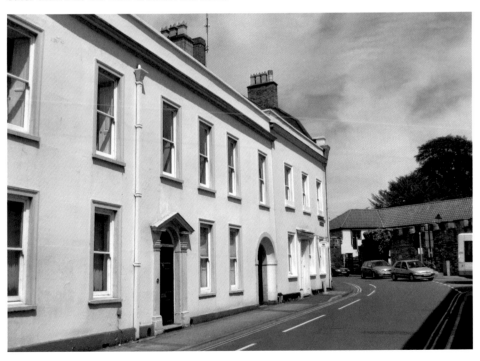

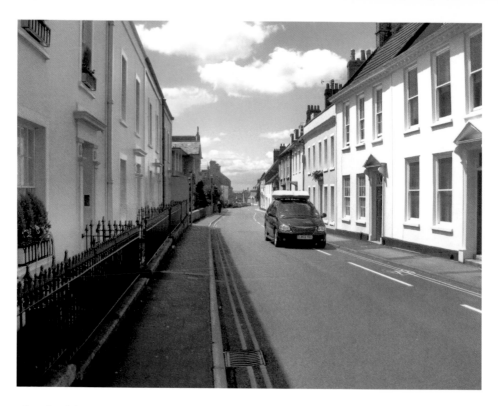

Chamberlain Street

The view down Chamberlain Street from the Sadler Street junction is also very similar to that illustrated in the Phillips photograph. The Catholic church can be made out half way down the street on the left hand side.

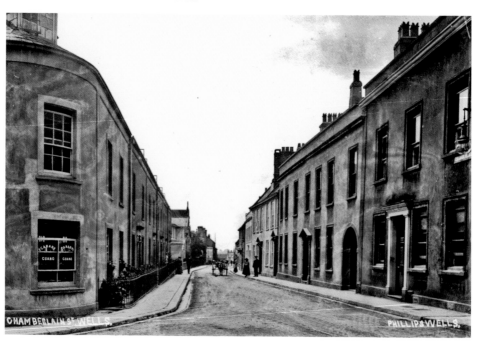

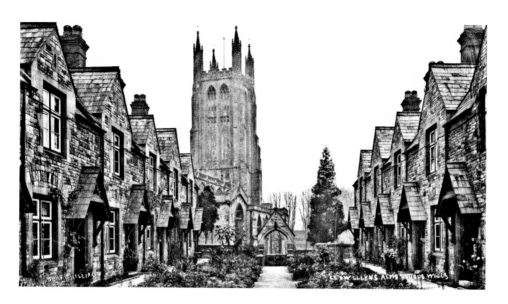

Llewellyn's Alms Houses

In 1604 Alderman Henry Llewellyn provided for the building of an almshouse for ten elderly women. His trustees bought land on the east side of Priest's Row and the almshouses opened in 1630. The present range is a Victorian replacement for the original buildings. Bubwith's Almshouses, situated on the north side of St Cuthbert's churchyard, were founded by Bishop Bubwith *c.* 1436 for twelve poor women and twelve poor men. During the early seventeenth century they were extended by Bishop Still, then in 1638 by Walter Bricke, a wealthy woollen draper, and in 1777 by Edward Willes, son of another bishop. The whole complex was further altered in the nineteenth century. Our modern photograph shows the four curious canopied seats that date from 1638 and face the churchyard. Both sets of almshouses have remained much the same since Bert Phillips took the first photograph over one hundred years ago.

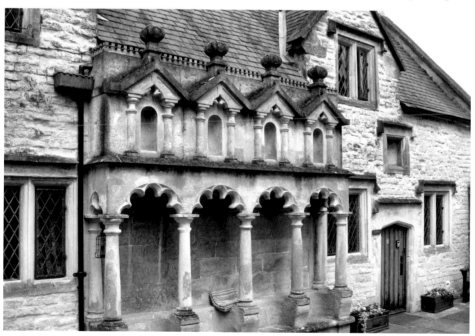

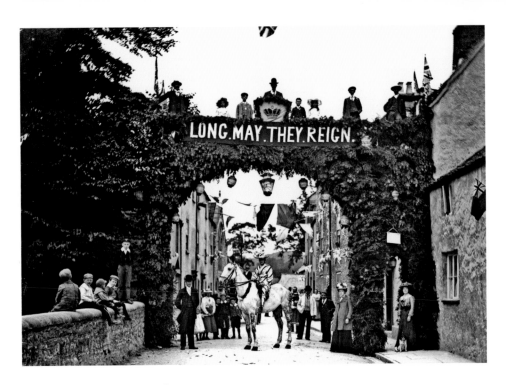

Priest Row Coronation Arch

A turning to the left just past Llewellyn's Almhouse brings us to Priest Row. In 1902 it was decorated with an arch created to celebrate the coronation of King Edward VII. It has been suggested that the arch was the inspiration of the landlord of the Globe Inn, just behind it on the right hand side of the road. The low wall on the left marks the boundary of St Cuthbert's churchyard. The Phillips picture shows Priest Row, looking up towards Chamberlain Street. The modern photograph shows the Globe Inn today.

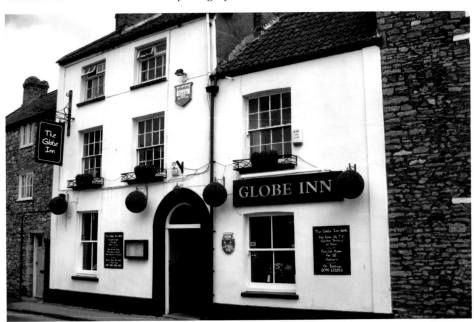

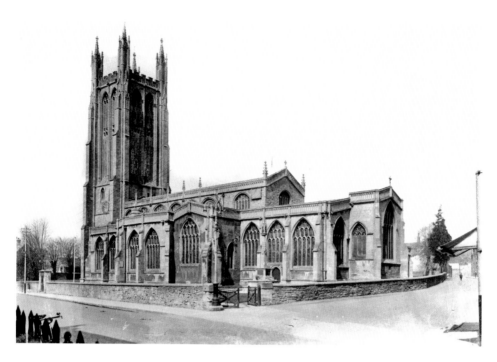

St Cuthbert's Church

St Cuthbert's is the parish church of Wells and the largest church in Somerset. The exterior is nearly all perpendicular in style and the tower is a magnificent 153 feet high. Little has changed since our earlier photograph was taken, except for the increased activity apparent on a pleasant Saturday in May.

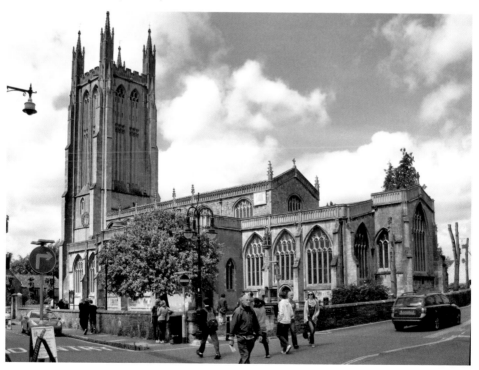

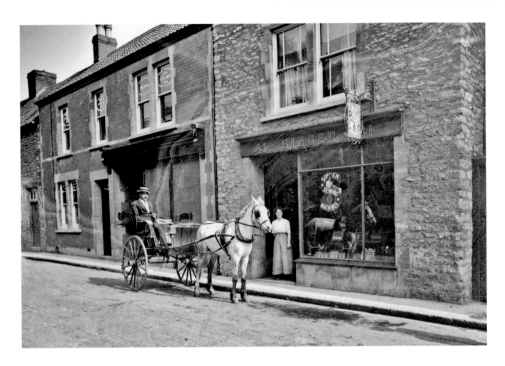

The Singer Sewing Machine Shop

Singer Sewing Machines were sold at No. 41 St Cuthbert Street. The Phillips photograph features a splendid horse and trap driven by a gentleman sporting a rather natty boater. No. 41 is currently home to a launderette, and the horse and trap has been replaced by the ubiquitous motor car.

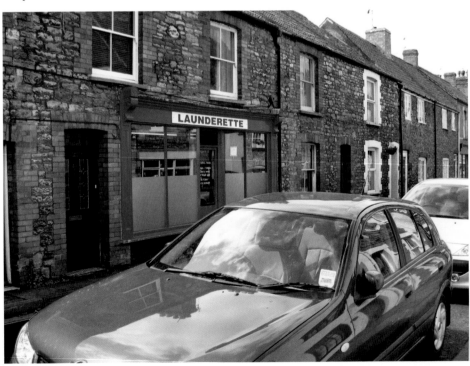

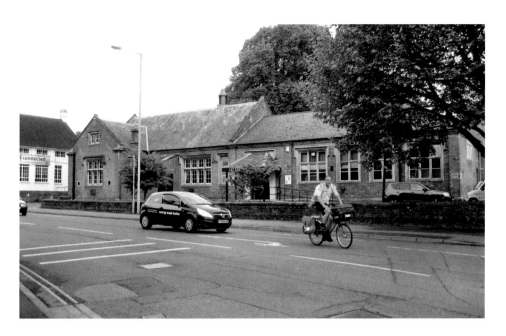

The Blue School

The Wells Little Theatre is now situated opposite Portway, at the bottom of Chamberlain Street. The building was formerly the boy's division of the well-known Blue School, whose origins lay in the mid-seventeenth century, when a charity school was founded in the city. Initially the school used the chapel at the Bubwith Almshouse as a classroom, but in 1723 it moved to North Liberty. About a century later it acquired Soho House in Chamberlain Street. By then it was known as the Blue School, from the colour of its uniform. Shortly before the First World War it was rebuilt, and at the same time an annexe was created for the girls on the corner of Portway and Portway Avenue, seen here in our Phillips photograph. The school has now moved again and the one-time girls' division is an adult education centre.

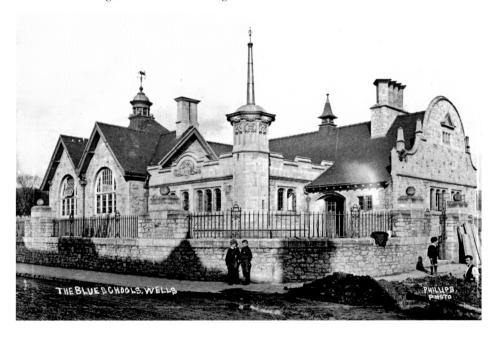

THE BLUE SCHOOLS, WELLS

PHILLIPS PHOTO

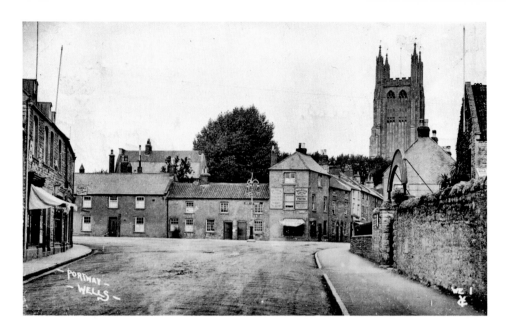

And Then There was Tesco

This Edwardian view of Tucker Street looks up towards its junction with Portway and Chamberlain Street on the left and St Cuthbert's Street and Market Street to the right. The cottage to the left-centre has long since disappeared and has been replaced by the Little Theatre's car-park. Another change, and perhaps a more significant one, has occurred on the right hand side of the picture. Behind what were then a stone wall and an archway leading into the Priory Nurseries lies a thriving branch of Tesco.

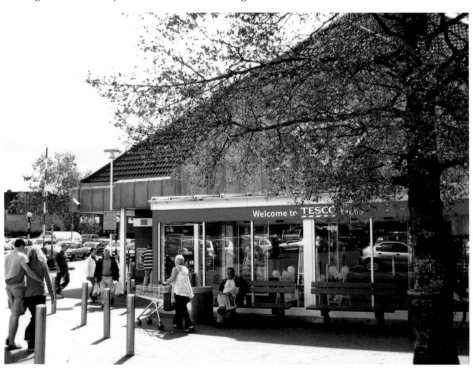

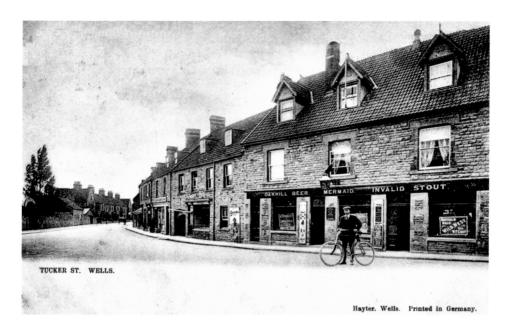

TUCKER ST. WELLS.

Hayter. Wells. Printed in Germany.

The Mermaid and the Cheddar Valley

The Mermaid and the Cheddar Valley are the two pubs in Tucker Street that would have been very familiar to travellers leaving their trains at Tucker Street Station. The Mermaid dates back to the sixteenth century, although the present building is Victorian and currently unoccupied, while the Cheddar Valley takes its name from the railway line of that name, a subsidiary of the Bristol & Exeter Railway that was later absorbed by the Great Western Railway (GWR).

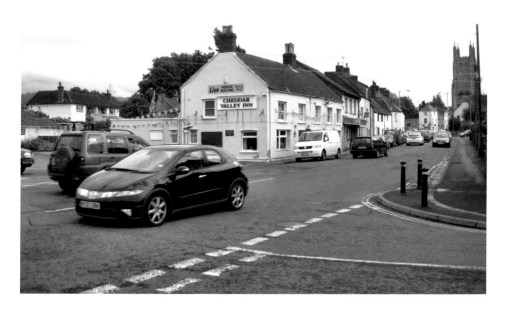

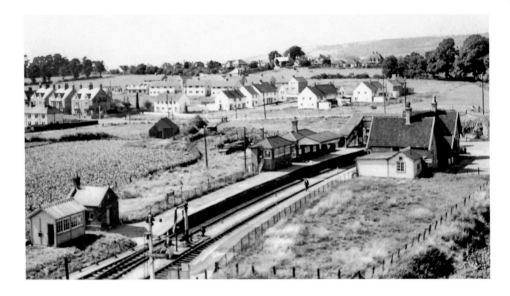

Tucker Street Station Aerial View

The Bristol & Exeter Railway Company came into being in 1861, and it survived for a little over fifteen years before being taken over. Its Cheddar Valley line, which went through Wells, was in fact the third railway to reach Wells, although one, the East Somerset, closed in 1878, and the Cheddar Valley station at Tucker Street opened in April 1870. Our aerial photograph shows the station with Burcott Road in the middle distance. The Burcott Road Bridge is just visible behind the station building. The modern picture is of the former goods shed, all that remains of the station.

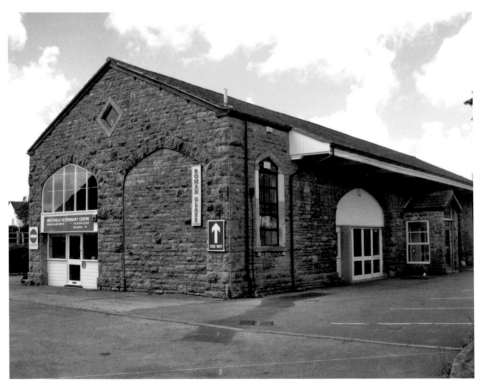

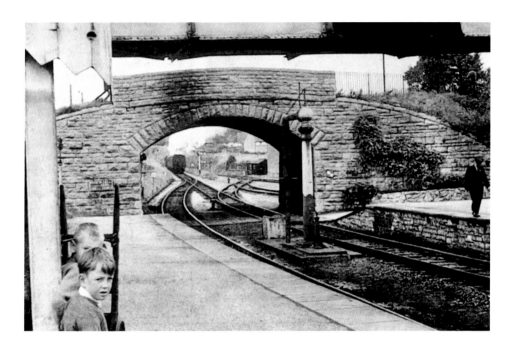

The Burcott Road Bridge

The bridge which carried road traffic across the line is seen in this photograph, which must date from the 1950s. Burcott Road is to the photographer's left, Tucker Street itself to the right and the view up the track is to the north. The main road that follows the line of the track is called Strawberry Way, in memory of the strawberries from the Cheddar Valley that used to be seasonal freight. The bridge has vanished – to be replaced by traffic lights – but its stone was used to create three roadside markers to commemorate the city's three former railway stations. Strawberry Way follows the line of the old railway as it heads towards the Burcott Road traffic lights. The one-time goods shed is clearly visible on the left hand side of the road.

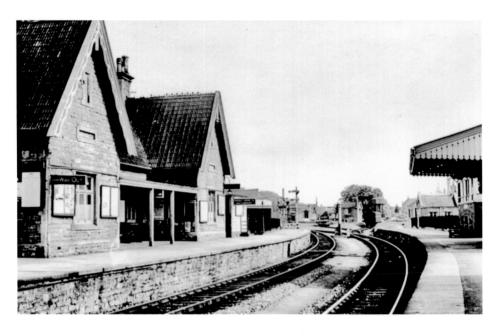

Tucker Street Station Looking East

Tucker Street, the station for the Bristol & Exeter, then the GWR, was an attractive twin-gabled building constructed of local stone. It had two platforms, ample waiting rooms and good office and staff accommodation. The station closed to passengers in 1963 and to freight six years later. The whole area is now taken up by a car park and a complex of modern town houses.

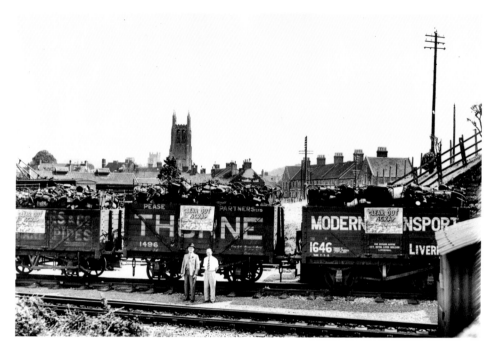

Tucker Street Station at War

Three wagons loaded with scrap for the war effort feature on this 1940s photograph of the GWR siding at Tucker Street. The terraced cottages to the right still remain to this day, and in the distance one can clearly make out the steeple of St Cuthbert's church. The embankment to the right, which carries the road over the Burcott Bridge, has subsequently been levelled and the photographer must have been standing somewhere near the fire station training tower clearly visible in our modern photograph.

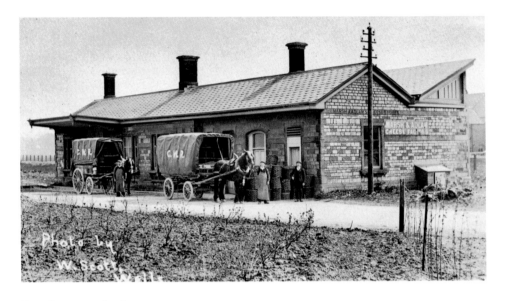

East Somerset Station

A short way down the line from Tucker Street was the first of two Priory Road stations, one on each side of the road. These were the Somerset Central station (the Somerset & Dorset after 1874), and then that of the East Somerset (the GWR after 1876). This photograph by W. Scott is a rare image of the East Somerset station, which opened in 1862, but closed fourteen years later when the company was taken over. The old station building was destroyed by fire in 1929; it was then doing service as a cheese store, as can be seen by the legend 'Marsh & Adlam Cheese Factors' which is visible on the wall. All traces of the station have now completely disappeared and the only reminder of a line that prided itself on a fast service to Bristol is the roadside marker and the name given to the new relief road that runs parallel to its track.

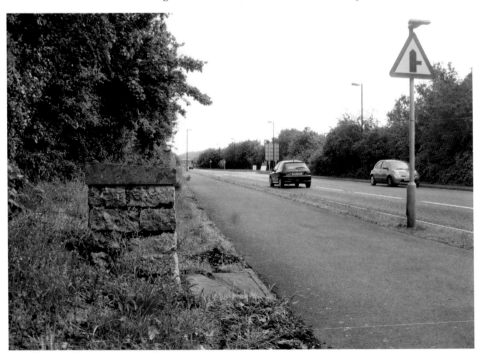

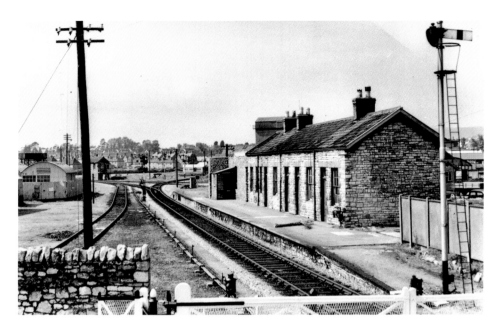

Priory Road Station

Strangely enough, although GWR trains steamed through the S&D station at Priory Road from about 1877, they did not stop there until 1934, fourteen years before nationalisation. Nothing now remains of the station, which closed in 1951, and the site is now occupied by the premises of Messrs Travis Perkins. This photograph was taken after the removal of the engine shed that covered the platform.

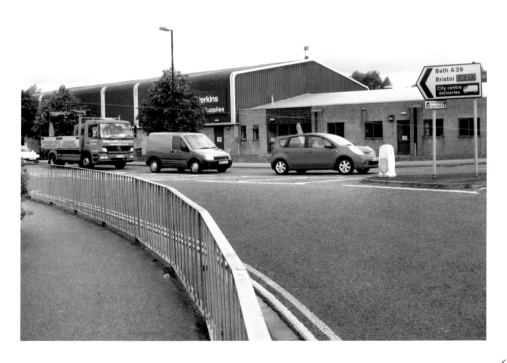

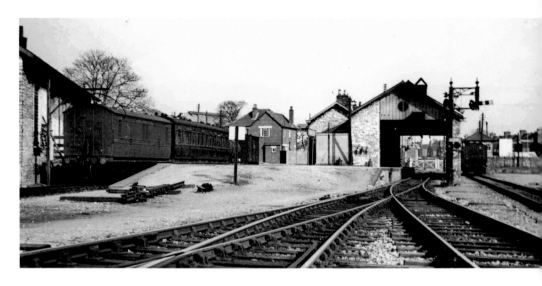

Priory Road Station Engine Shed
Our view to the east shows the engine shed, with the level crossing gates beyond it and the station master's house to the left. Once again we are on Travis Perkins territory.

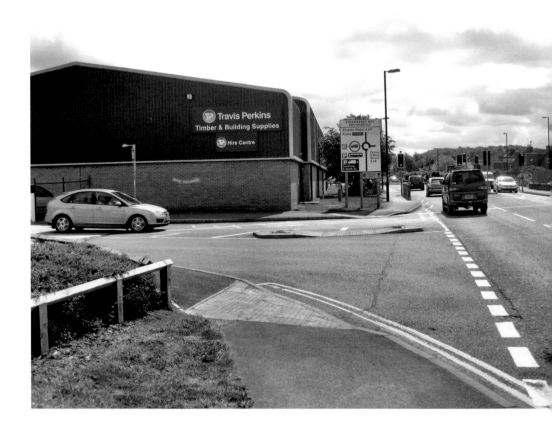

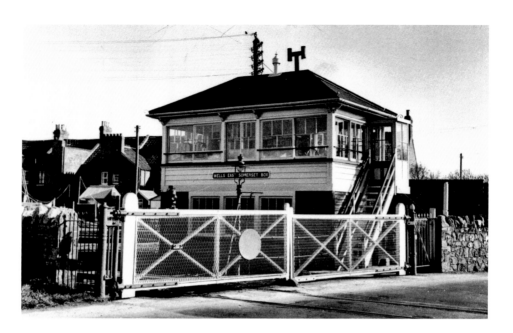

Priory Road Signal Box

The East Somerset signal box on Glastonbury Road is seen here, with houses in Rowdens Road on the left hand side. The line to the right leads into Priory Road Station and the photographer is standing on the Priory Road side of the level crossing gates. The houses are still there at the present time, while a pedestrian in a blue jersey wanders over the site of the signal box.

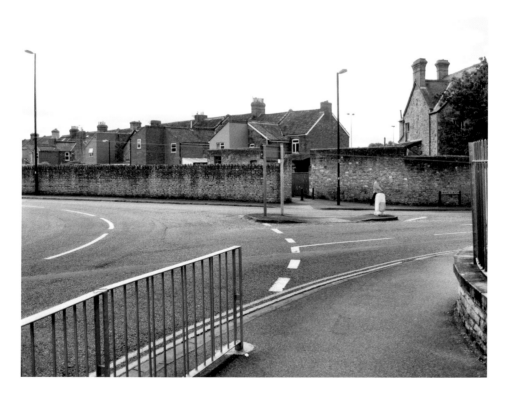

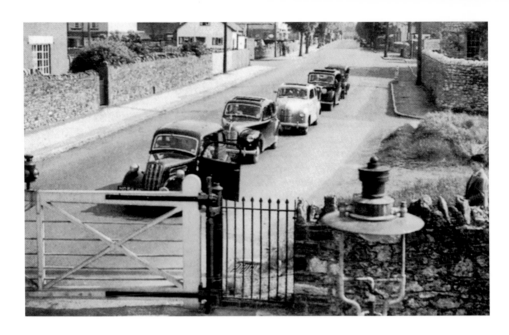

The Priory Road Level Crossing

The Priory Road level crossing caused a great deal of aggravation to motorists wanting to cross the line and drive on towards Glastonbury. This photograph of the offending gates dates from about 1955 and features five cars, and a small boy waiting for something exciting to happen. West Street can be seen on the left hand side, and nearly opposite it on the right one can make out Southover. The roundabout that occupies the site is to be seen in the lower picture.

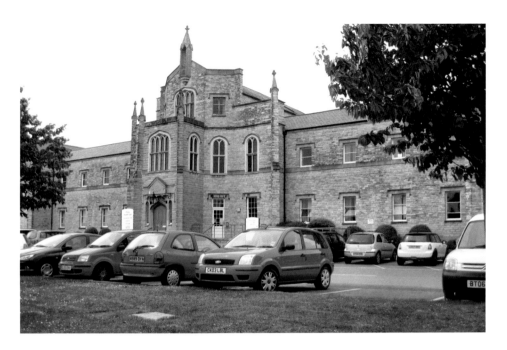

The Prince of Wales' Visit

Having negotiated the level crossing, the motorist travelling to Glastonbury would then pass the Union Workhouse on the right hand side of the road. The workhouse was built in 1837 and renamed the Wells Infirmary in 1948; it still exists today as the Priory Hospital. The Prince and Princess of Wales visited Wells in 1909 to commemorate the city's Millenary celebrations and the Phillips City Studio produced the lower photograph of the royal couple driving past the Union Workhouse. At a guess, it would appear that members of the staff of the institution are standing behind the railings, inmates are facing the royal cars and members of the general public in their Sunday best have their backs to the photographer.

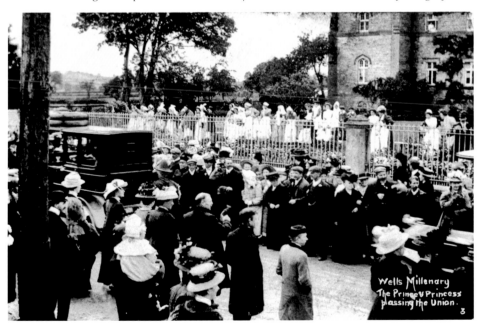

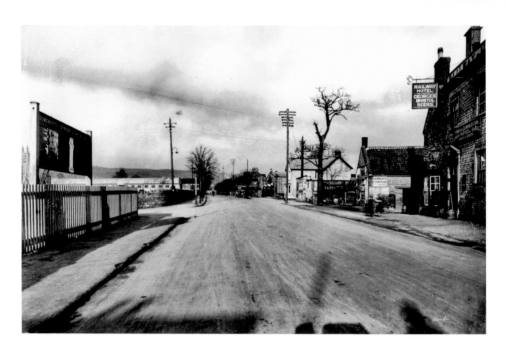

Priory Road Looking East

This photograph was taken from just above the level crossing gates in Priory Road, but long before the left hand side of the road was developed. The Somerset & Dorset Joint Railway sign is clearly visible on the left, and on the right is the Railway Hotel, now renamed the Sherston Inn. A close look at the pedimented door frame and the window lay-out in the modern photograph is enough to remind one that it is the same building.

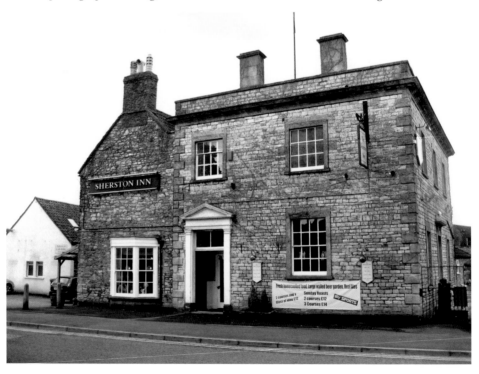

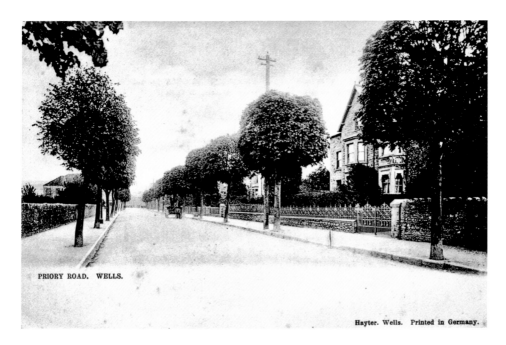

PRIORY ROAD. WELLS.

Hayter. Wells. Printed in Germany.

Priory Road Looking East

Priory Road takes its name from St John's Priory, founded in the thirteenth century and dissolved in 1539. It was created in the 1830s to become the main road out of the city to Glastonbury. Before then, travellers used St John's Street and Southover. Both views show the road from a vantage point well east of the level crossing and looking in the direction of Broad Street. The house on the right hand side of the earlier picture still remains.

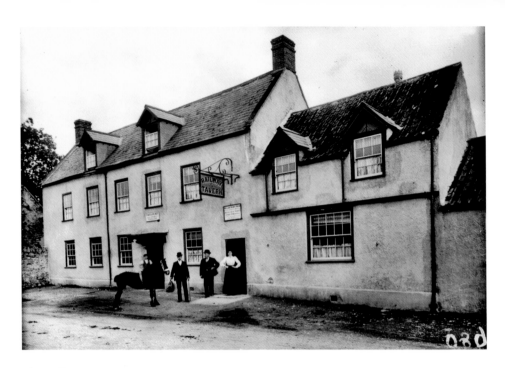

The Railway Tavern

Southover is a right hand turning just past the Priory Road level crossing, and the former Railway Tavern is at No. 33. It had been a beer house from the early years of Queen Victoria's reign and was formerly known as the Traveller's Rest; the name change was due to its proximity to Priory Road Station. The one-time pub has now been turned into housing.

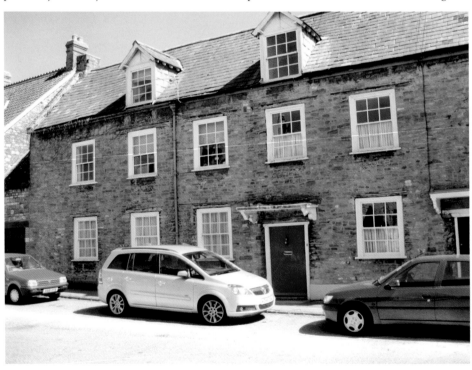

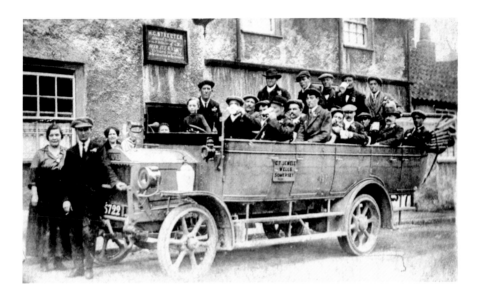

Charabanc Outing

The charabanc parked outside the Railway Tavern in our first picture was supplied by Jewell's of Priory Road. Its occupants are clearly knocking back the drinks they have just purchased from Mr Streeter, the pub's proprietor, before setting out on their excursion. The blue door seen below is a modern addition and H. G. Streeter's sign board was located just above the red one.

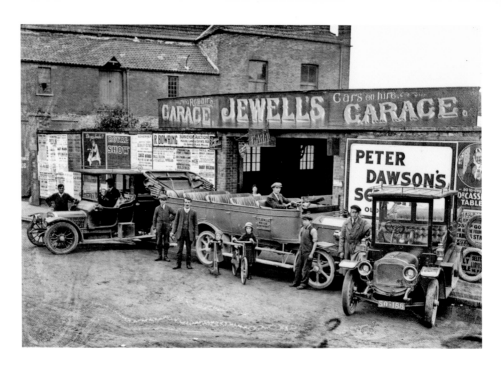

Jewell's Garage

Jewell's garage, next to the Palace Theatre, is seen in our Phillips photograph, together with a selection of classic cars. The Palace Theatre itself was formerly a bottling factory, then a theatre, and finally in the 1930s it became a cinema and was able to offer an alternative to the Regal Cinema on the corner of Priory Road and Prince's Road. It was demolished in 1998, while the Art Deco Regal now survives as a night club.

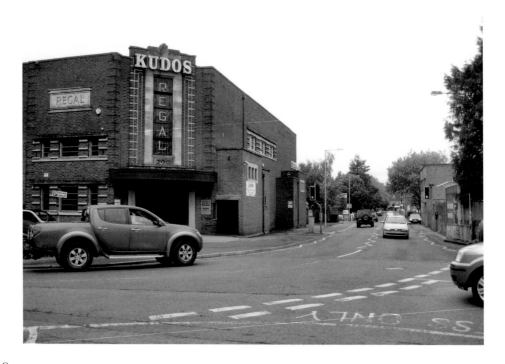

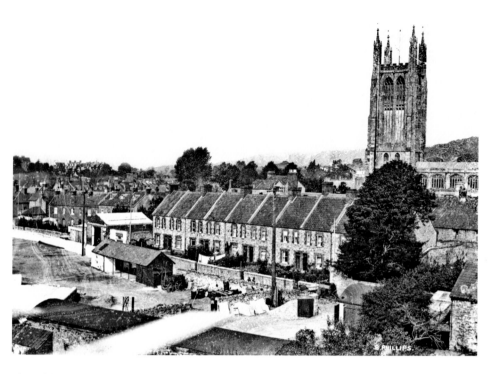

The Old Cattle Market in Prince's Road

The right hand side of Prince's Road as it heads in the direction of the junction of St Cuthbert Street and Tucker Street was once the cattle market. It was a derelict site when Phillips City Studio captured the view and is now a car and coach park.

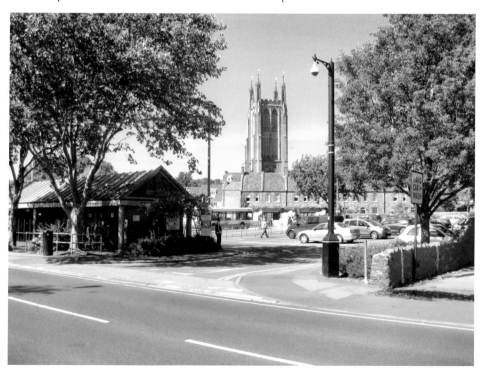

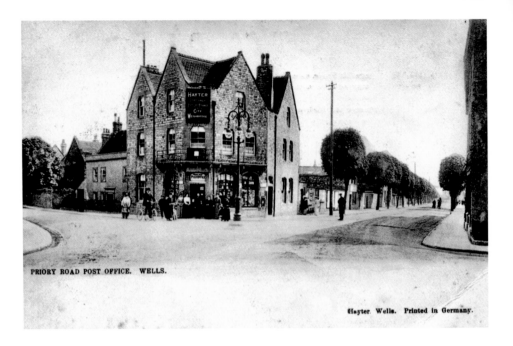

PRIORY ROAD POST OFFICE. WELLS.

Hayter. Wells. Printed in Germany.

Priory Road Post Office

Charles Hayter is unlikely to have been regarded as a rival to the Phillips City Studio, despite the rather attractive postcards he published. This one shows his post office, now an estate agent's, with Priory Road centre right, St John's Street off to the left and Queen Street to the right. The photographer has his back to Broad Street. The post office was known as Queen's Cross Post Office – the name commemorating the old market cross that used to stand in the centre of the crossroads.

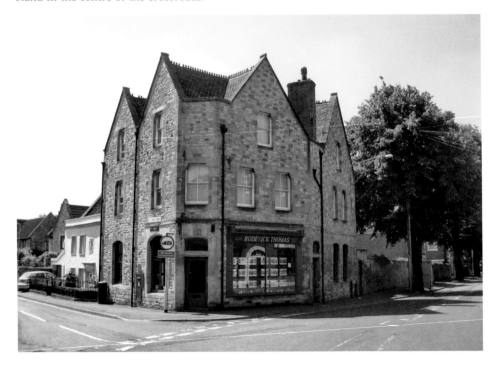

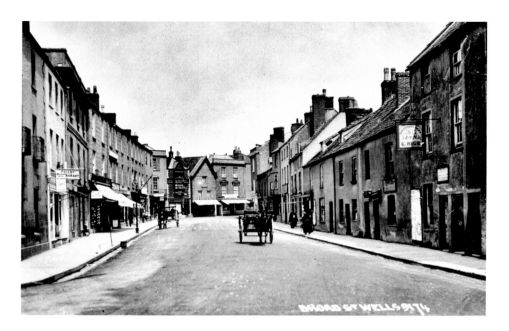

Broad Street

This would have been the view if the Hayter photographer had turned round. Previously known as Wet Lane, the street was widened in the 1830s – hence its new name. Today it is a one-way street, but before the creation of the various relief roads in the 1970s it would have carried travellers up to the High Street, then to Sadler Street and New Street and on to Bath, Bristol and the north.

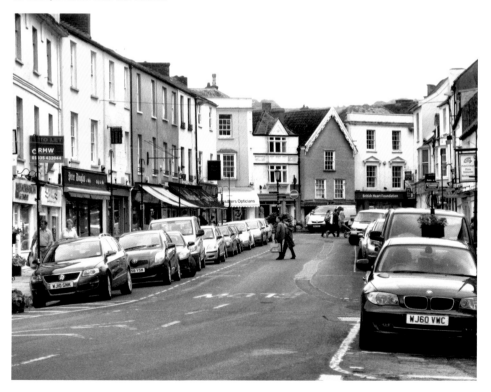

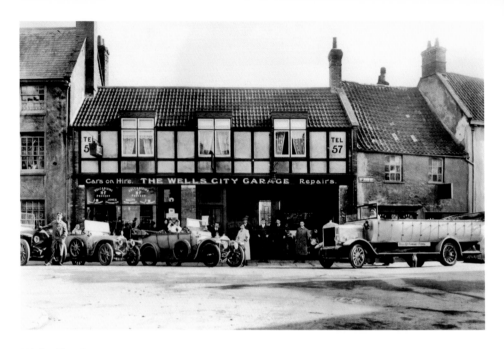

Wells City Garage

The Wells City Garage at No. 29 Broad Street provided opposition to Jewell's of Priory Street when it came to motor cars during the early 1920s. Our photograph features a selection of superior vehicles, together with their smartly dressed drivers. The premises are currently occupied by two very different concerns.

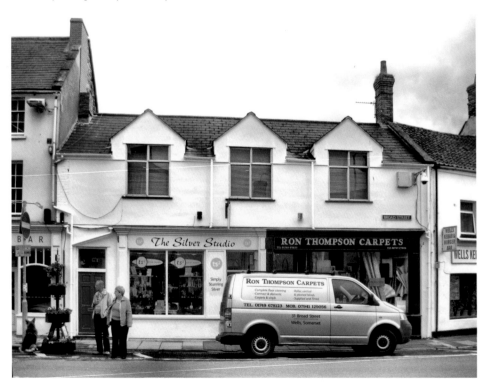

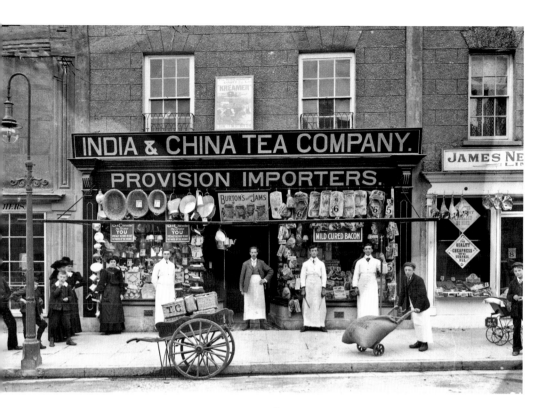

Nelson's, No. 10 Broad Street
Nelson's at No. 10 Broad Street, on the opposite side of the road, was first and foremost a grocer's shop but clearly dabbled in ironmongery as well. Now it is all change and the premises are occupied by a gentleman's outfitters.

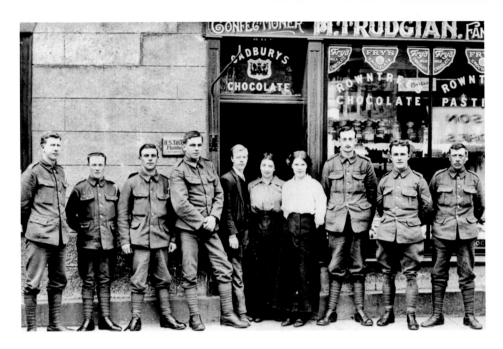

Trudgian's, No. 2 Broad Street
Another change here, with M. Trudgian the confectioner being replaced by Microbitz, a computer shop. The seven uniformed figures give the earlier picture a wartime flavour and the photographer was Bert Phillips.

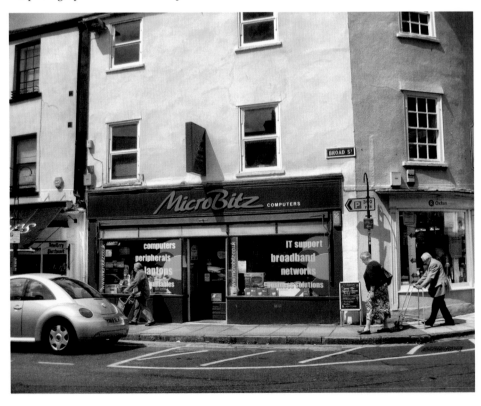

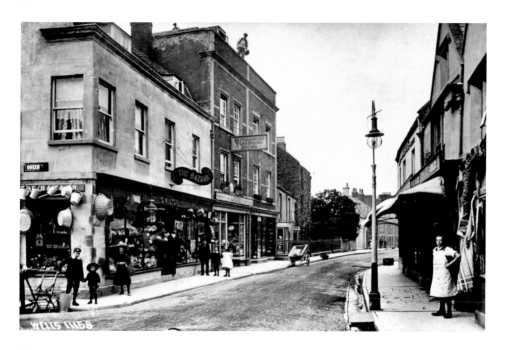

Queen Street

At the bottom of the High Street, Queen Street is just beyond the Broad Street junction. The turning is seen here on the left hand side and the word Queen can be made out on the earlier photograph, produced as a postcard by Chapman & Son of Dawlish.

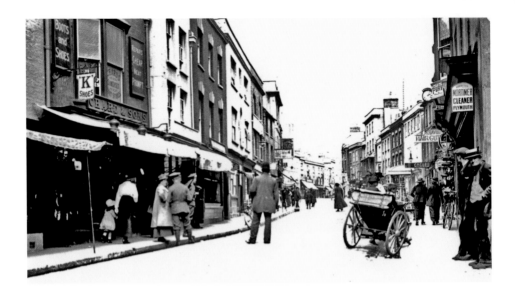

High Street

The traveller now enters the High Street. This Phillips view from its junction with Broad Street and St Cuthbert Street looks up towards the Market Place. The picture is enlivened by, among other things, two soldiers on the left hand side by Chard & Sons' shop, a cart and a pedestrian in a boater on the right, and two ladies in hobble skirts walking away from the cameraman in the middle distance.

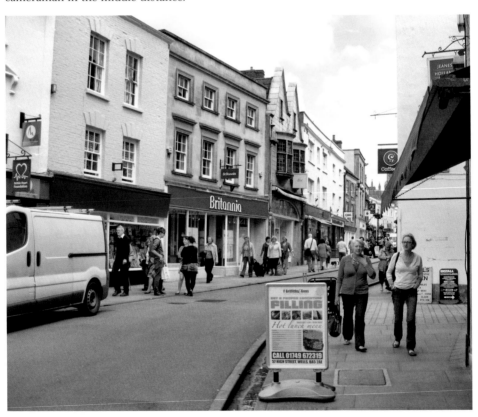

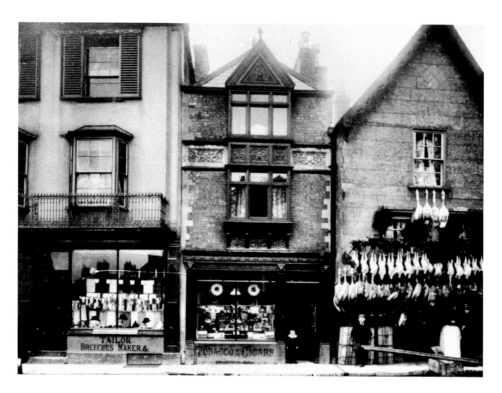

Three Shop Elevation

This splendid group of three shops is to be found on the left hand side of the High Street looking east in the direction of the Market Place, and luckily little has changed over the years apart from the occupancy of the buildings. When the Phillips City Studio took its photograph, the premises were occupied by a tailor and breeches maker, a tobacco and cigar seller, and a poulterer. These have since been replaced by an optician, a clothes shop and a wine seller. The spectacular roofline, however, remains identical.

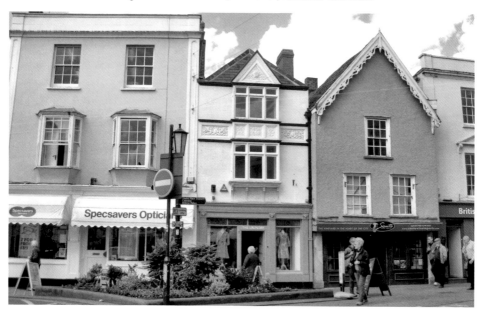

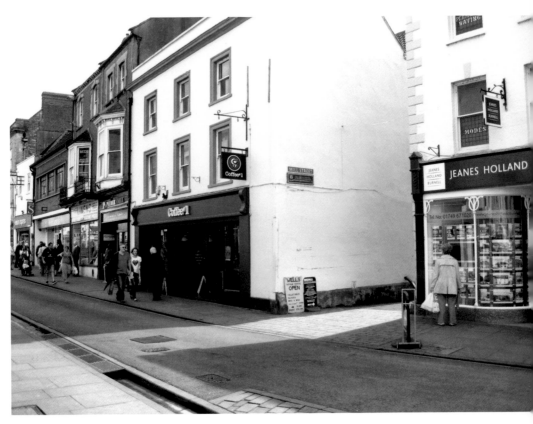

Tyte's, No. 51 High Street

Coffee 1 now occupies this shop on the corner of the High Street and Mill Street. In earlier days it was a grocer's, and the proprietor was 'tubby old Mr Tyte with a huge long apron and tiny little glasses on the end of his nose'. The late Georgian façade of the building dates from the time when it enjoyed an existence as the King's Arms, one of the twenty-nine inns and hotels listed in the city in 1840.

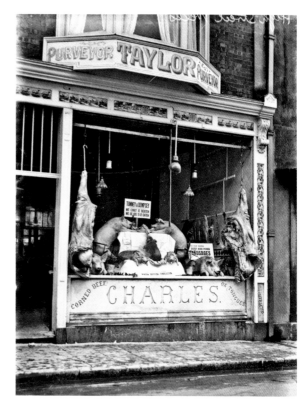

Taylor's, No. 53 High Street
Next door at No. 53, Taylor's butcher's shop has removable windows or shutters that allow the display of meat to overflow into the area above the pavement – a practice that would clearly not find favour today. There are also rather charming decorative tiles surrounding the shop front. All these features have long gone and the premises are now occupied by an estate agency.

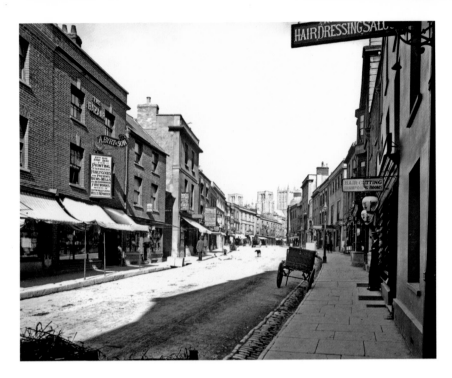

High Street and the King's Head

Further up the street, one has the King's Head public house on the left hand side of the picture. A man stands beneath the sign board outside the inn that reads 'Posting House. Landaus. Breaks. Waggonettes. Dogcarts. Saddle Horses. Good Beds. Chops and Steaks Cooked. Commercial & Cyclist.' The sign at present advertises 'Real Food, Cask Ale & Great Coffee.'

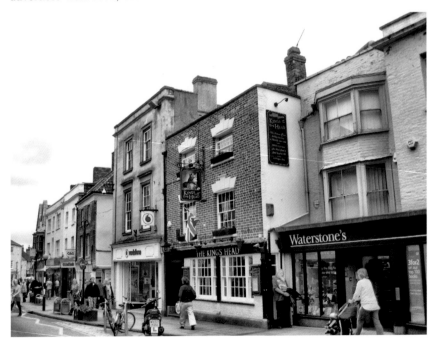

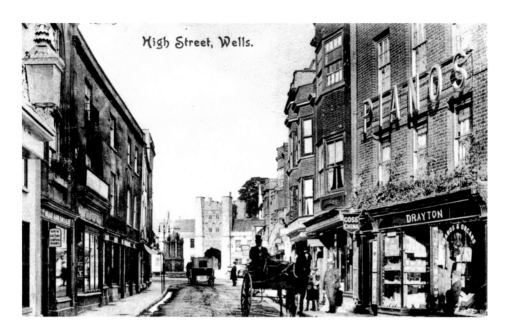

High Street, Wells.

High Street and Drayton's Shop

This postcard showing the eastern end of the High Street with the Market Place clearly in view was the work of Harvey Barton and Son Ltd. of Bristol rather than the Phillips City Studio. Drayton's piano shop is clearly visible on the right hand side and the photograph also features a picturesque horse and trap in the foreground, as well as a rather more cumbersome closed carriage heading in the direction of the fountain. Today, the premises are up for letting.

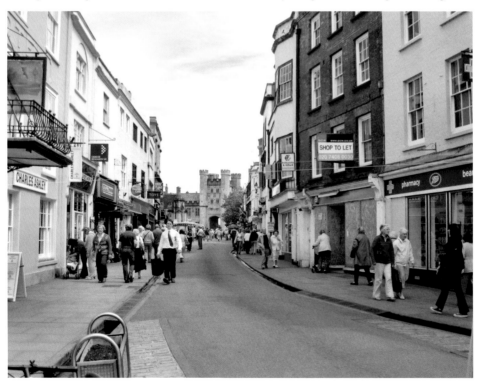

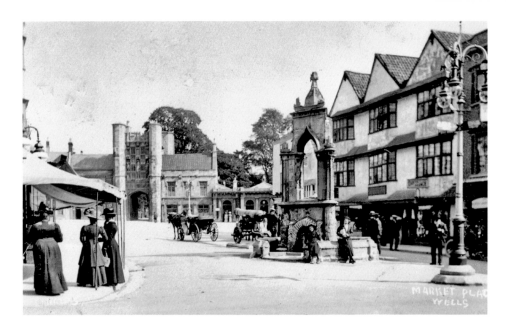

Market Place with 3 Ladies

We return to the Market Place, this time on the opposite side of the road to our vantage point on page 5. On this occasion, three ladies in hats and long dark costumes occupy the left foreground and we get a splendid view of the Crown Hotel beyond the fountain. In many ways the outlook today is very similar to that seen by our photographer shortly before the First World War.

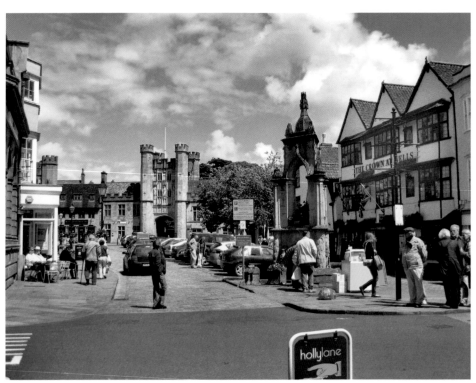

Market Place Looking West

Chapman & Son were responsible for this unusual inter-war picture of the Market Place, looking towards the west. The High Street is straight ahead, beyond the fountain, and Sadler Street goes off to the right. Things look almost as peaceful seventy years later, although the central row of parked cards hints at activity in the shops and restaurants around the square.

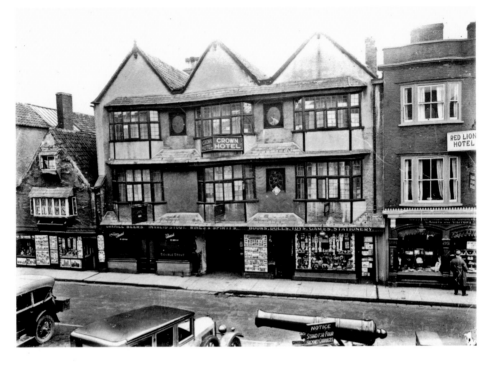

No. 4 Market Place

Here we have another inter-war photograph, this time looking across the Russian gun towards the Crown Hotel. After the first war, No. 4 Market Place, the premises to the right, was acquired by Bert Phillips, who ran it as a toy and novelty shop. Now it has a new life as Anton's Bistrot and Wine Bar.

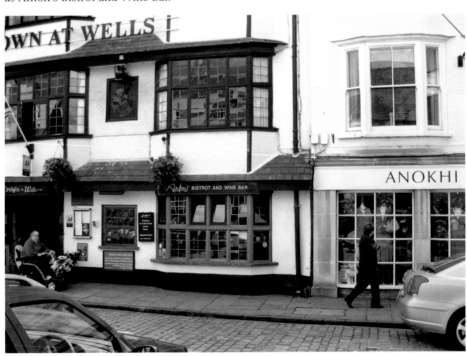

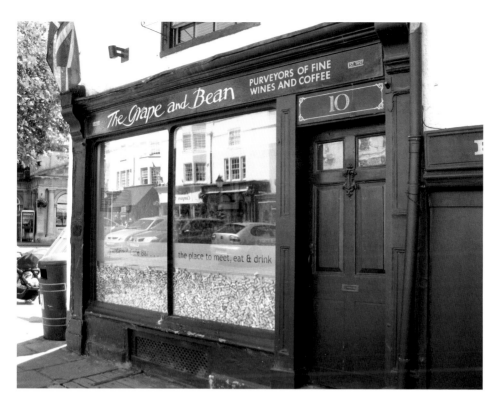

The Phillips City Studio at No. 10 Market Place

Like Anton's, the Grape and Bean wine bar is now part of the Crown Hotel. In Edwardian days, as No. 10 Market Place, it was the home of the Phillips City Studio. The premises comprised a studio and two bedrooms on the top floor, a living room and a bedroom on the first floor, the shop and a kitchen on the ground floor and a darkroom in the cellar.

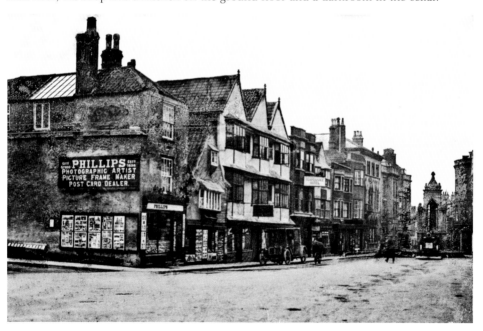

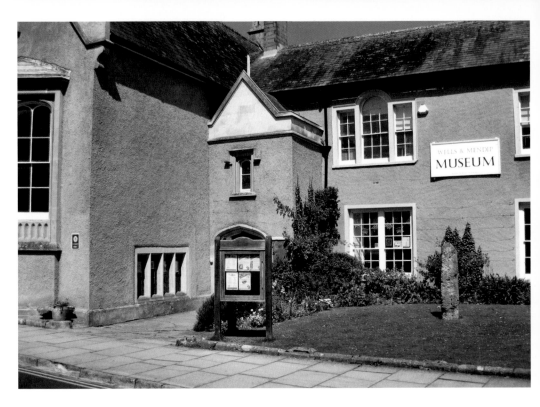

The Wells Museum
About a thousand Phillips City Studio plates are to be found in the Wells Museum, a building on Cathedral Green that dates from the sixteenth century, but which was considerably altered in the eighteenth and nineteenth. Since 1930 it has been the home of the museum and contains major archaeological and geological collections, as well as an important local history collection and a significant reference library.

Acknowledgements

First and foremost I have to thank Wells Museum and its curator, Barry Lane, for allowing me to make use of the Phillips Archive, which has provided the greater part of the old photographs used in this book. Other images were supplied by Jeffrey Allen (numbers 62, 66, 69, 71, 75, 8 84, 85 and 93), Paul Fry (numbers 64 and 70) and Patrick Hopton (numbers 65, 72, 73 and 77 My thanks go to all of them and also to Jerry Sampson, who provided information on Penniles Porch and the Bishop's Eye, and to Peter James for his help with the graphics. All other picture come from my own collection.

I am grateful for the permission received from the management of The Swan Hotel tha enabled me to take the modern photograph on page 23. The quotation on page 88 first appeare in *Wells in Old Photographs* by Chris Howell, published by Alan Sutton in 1989.